LYTHAM
ST ANNES

THE POSTCARD COLLECTION

Peter Byrom

To Martin & Norma,
This is to remind you of your
happy times in Lytham
St. Annes, all the very Best
to you both,
Peter & Pauline

AMBERLEY

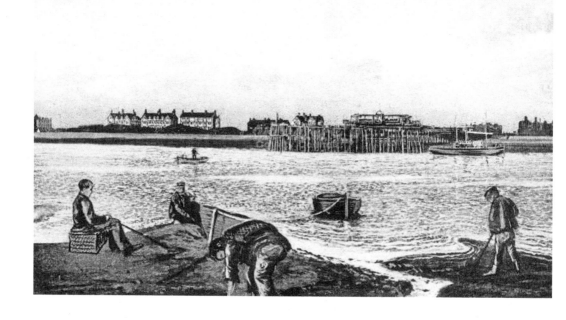

I would like to dedicate this book to my wife Audrey for her patience and understanding, suffering long periods of silence while I compiled it; also my daughter Alison, her husband David for his IT assistance and to my grandchildren and great-grandchildren, Daniel, Lauren and Megan Skye and Sophie Rae respectfully. The postcard images used are from my own collection and the collection of the late James Lee courtesy of his wife Sylvie.

First published 2016

Amberley Publishing
The Hill, Stroud, Gloucestershire, GL5 4EP
www.amberley-books.com

Copyright © Peter Byrom, 2016

The right of Peter Byrom to be identified as the
Author of this work has been asserted in accordance with
the Copyrights, Designs and Patents Act 1988.

ISBN 978 1 4456 5793 6 (print)
ISBN 978 1 4456 5794 3 (ebook)

British Library Cataloguing in Publication Data.
A catalogue record for this book is available from the
British Library.

Typesetting by Amberley Publishing.
Printed in Great Britain.

INTRODUCTION

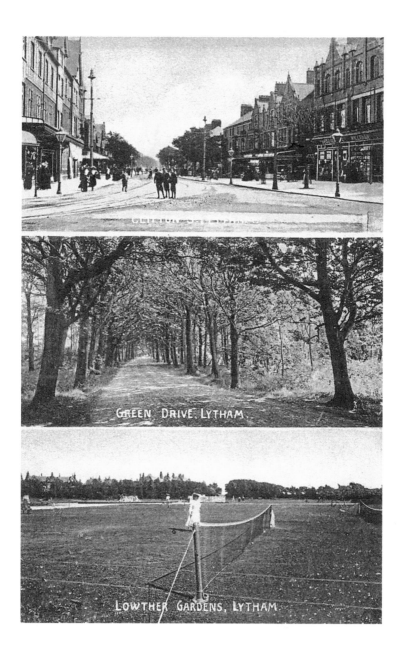

GREEN DRIVE, LYTHAM

LOWTHER GARDENS, LYTHAM

Where the Irish sea touches Lancashire there is an area known as the Hundred of Amounderness, part of it became known as the Fylde in which, during the Middle Ages and later were the villages of Thornton, Bispham, and Lytham, (Cleveley's, Blackpool and St Annes being a product of later times) In AD 600 the area is thought to have been settled by Anglo-Saxons and in AD 900 a huge influx of Irish, Norse Vikings who were expelled from Dublin, Ireland arrived. They became overlords of the area including the before-mentioned villages and after the Norman invasion, they became Norman Thanes. From then on, apart from the Dissolution of the Monasteries, life plodded on fairly uneventfully up to the Industrial Revolution.

The Industrial Revolution (1760–1840) did not affect the Fylde coast straight away at the time, but it transformed, not only the inland towns of Lancashire but also Preston, which stands either side of the River Ribble, not far from Lytham and the Fylde. This revolution created a lot of wealthy mill owners and businessmen, who, with their families started travelling to the coast for holidays. The health benefits of fresh-water springs such as those at Bath and Buxton were already well known from Roman times and doctors believed that bathing and drinking sea water also had great health benefits, so popularising sea bathing around the British coast line which caused an increase in visitors to these areas.

The Cliftons, who were the main land owners in Lytham, oversaw the changes required as it changed from a farming and fishing village to a holiday resort and town.

Lytham's fortunes increased even more when a railway line was laid from Kirkham to a station in what is now known as Station Road in 1846, allowing even more wealthy visitors from the inland towns to travel easily to the resort. Another line was laid from Blackpool to a station in Ballam Road in 1863 and when it was rebuilt in 1874 the line was extended to the one in Station Road which was then closed to passenger traffic.

The original railway line from Ballam Road to Blackpool, a resort frequented mainly by the hard working-class people from the mill towns etc., passed through rabbit-infested sand dunes along the coast; it was approximately half way between these two towns that a businessman, Elijah Hargreaves, envisaged building a new town and resort on the coast. He with others formed the St Anne's Land & Building Co. and, renting land from Clifton Estates, laid the first stone for the first building in St Annes, the St Anne's Hotel in 1875.

The latter part of this preamble took place mainly in the late 1800s as did three other major events that make a book like this possible, namely:

The first photograph that was a clear picture was commercially introduced in 1839 and was classed as the birth of practical photography.

Secondly, on 1 May 1840, the first postage stamp (a penny black) was used.

Thirdly, the first postcard was sent to Theodore Hook from Fulham in London, England; it had a hand-painted design on it and a penny black stamp and it is thought Theodore probably created the postcard and sent it to himself.

It was in 1894 that British publishers were given permission by the Royal Mail to manufacture and distribute picture postcards which could be sent through the post; the early postcards were usually of landmarks, scenic views, or photographs/drawings of celebrities.

Peter Byrom
April 2016

LYTHAM

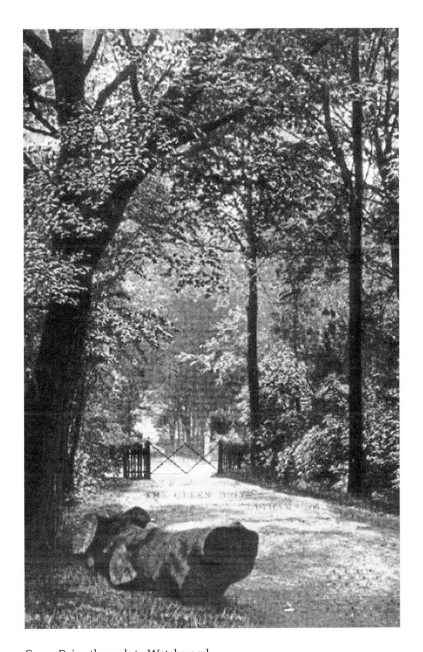

Green Drive through to Watchwood

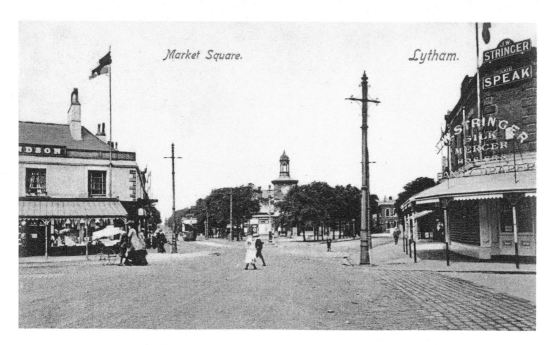

Market Square. *Lytham.*

Tram I

After the horse and carriage era there were two ways of arriving in Lytham, either by tram, which in the early days ran on gas then later electricity, or by train. The first picture shows one of the gas trams heading up Church Road on a single line from Fairhaven passing Market Square on the right to arrive in Clifton Square with Mondson's shop on the left and Stringer's on the right. The lower view is of Clifton Street with the electrification of the tramway complete which took place around 1904, but the only vehicle on the road is a motor bus.

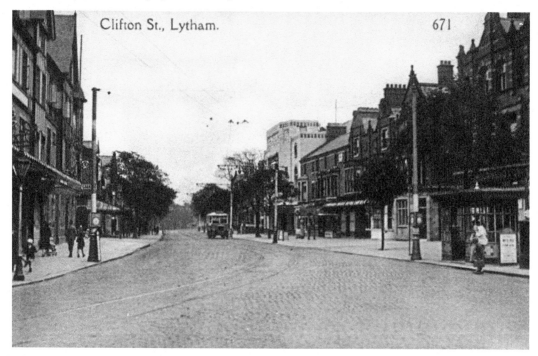

Clifton St., Lytham. 671

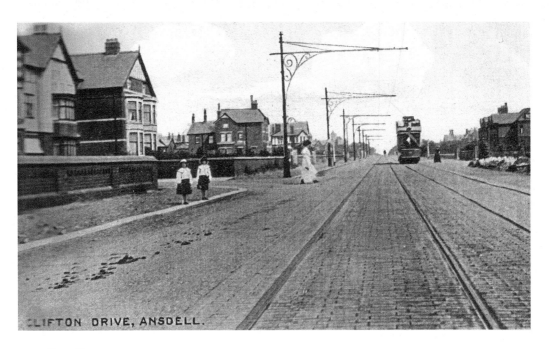

CLIFTON DRIVE, ANSDELL.

Tram II

A quiet day on South Clifton Drive with a tram travelling north to St Annes. I hope the lady in the white dress is watching where it is trailing on the floor what with all the horse droppings. The lower picture shows trams travelling up and down Ansdell Road South and both postcards show the tram system now electrified and judging by the white globes attached to each stanchion, it looks as if electric street lighting was being installed at the same time, replacing the gas lamps on the other side of the road.

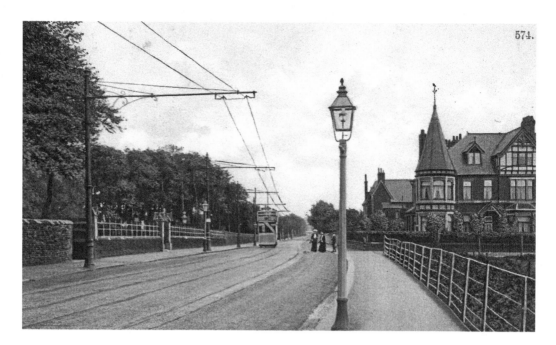

Church Road

Having left Fairhaven, the tram joins Church Road with St Cuthbert's church on the left (Church Road is part of the original cart track between Lytham and Blackpool) finally arriving outside the Ship Hotel, now called the Ship & Royal. The hotel is said to haunted by Charlie, a former regular, or John Talbot Clifton who is reported to have been seen on the second floor and is responsible for moving papers around and placing false orders to suppliers by phone.

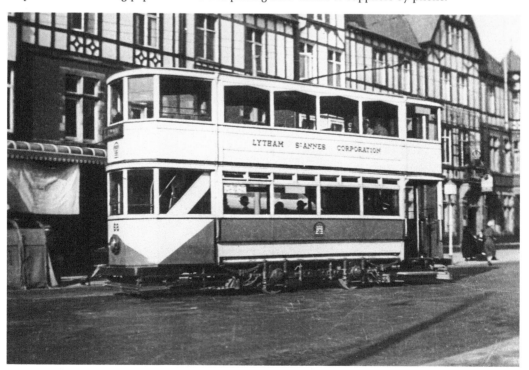

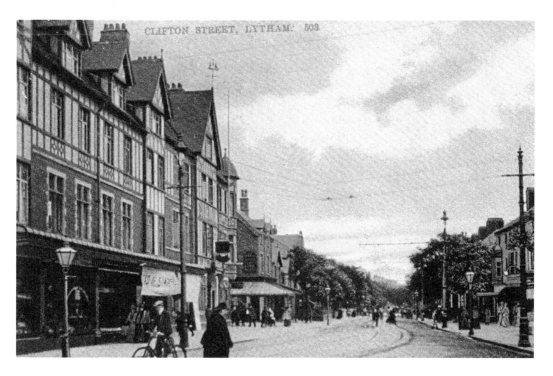

Clifton Street I

Two views of Clifton Street, one with the Ship & Royal on the left and the other showing the white top of the Palace Cinema above the trees. As mentioned on the previous page, the Ship & Royal is reputed to be haunted not only by the two men mentioned but also by a mother and daughter who committed suicide by drowning themselves in one of the upstairs bathrooms in the early twentieth century. There are twenty rooms on the upper floors and although there is now no plumbing in them, running water is often heard.

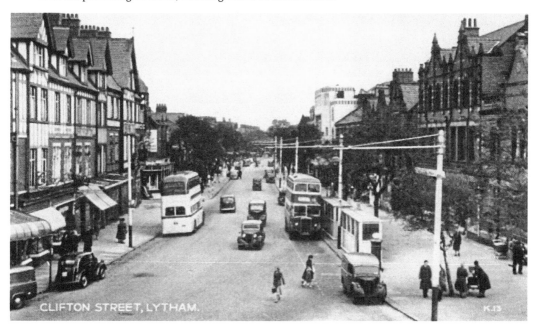

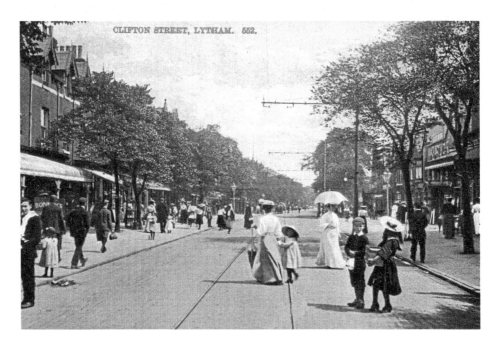

Clifton Street II

These two views were taken from nearly the same position on Clifton Street, the first looking down the street to the crossroads where it joins Warton Street and Station Road, aptly named because on the inland end of the road stood the original railway station, an impressive, medium-sized building, with four stone pillars at the front, (the site is now occupied by the fire station) with the old Railway Hotel (renamed the Railway Hotel from Hansom Cab in 2012) next to it. Looking the other way, the view is back to Clifton Square, the road being used by both electric and petrol vehicles and a pedestrian.

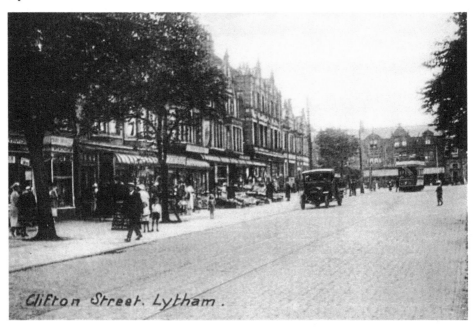

Clifton Street. Lytham.

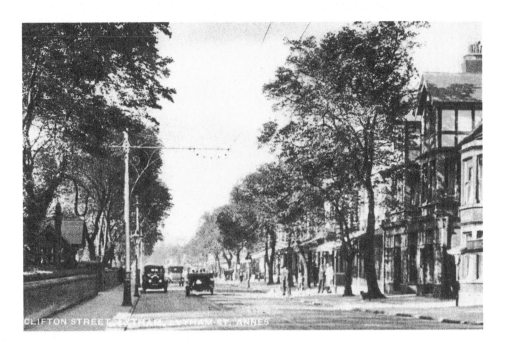

CLIFTON STREET, LYTHAM, LYTHAM ST. ANNES

St Peter's Church

The view taken from outside of the library (which was built by public subscription) looking towards Clifton Square shows the impressive lychgate on the left to St Peter's Catholic Church which was added in 1899. The church itself was opened in 1839 and was enlarged in 1874 with the tower and organ being added in 1878. The lychgate and a new porch were erected in 1909. A school was opened in 1852. Prior to this the Catholic congregation worshiped in a small chapel at Lytham Hall but when was closed to them they were allowed to use an old tithe barn in the estate grounds.

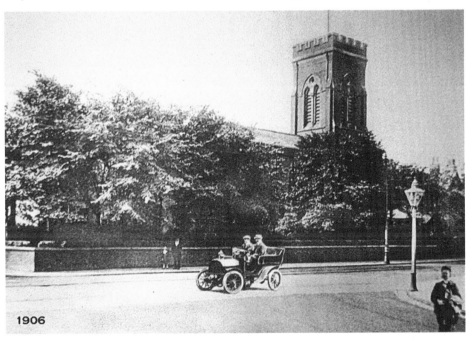

1906

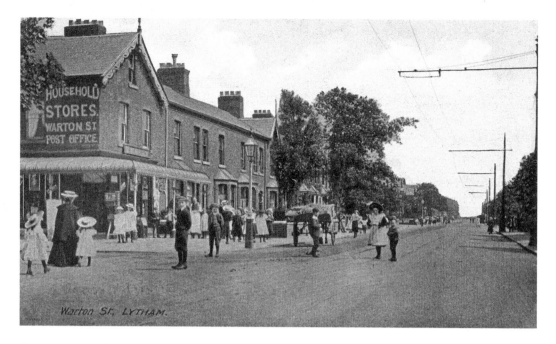

Warton St. Lytham.

Cottage Hospital

Warton Street as seen from Station Road to where it meets the promenade roads of East Beach and Preston Road. At this junction could be found Lytham Cottage Hospital whose foundation stone was laid in 1870 by Miss Constantine Wood who placed papers and coins in the cavity. It was constructed with cobble stones from the beach with brick corners and enlarged around 1882 to accommodate patients who lived within an eight-mile radius, anyone outside this radius having to pay. It was demolished in 2007 to make way for a modern medical centre. A 1920s time capsule was found at the time.

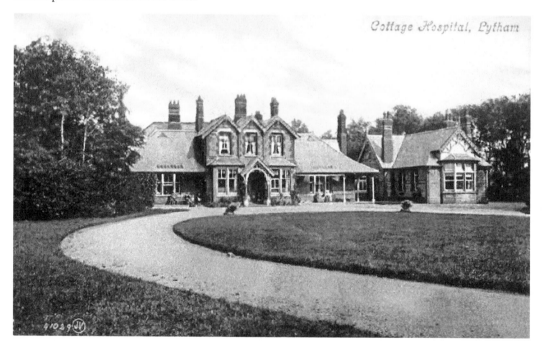

Cottage Hospital, Lytham

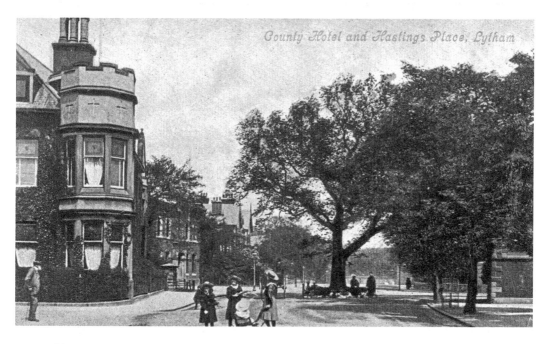

Old Tom

Back in the town centre by the County Hotel stood Old Tom reputedly the oldest elm tree in the area which is supposed to have stood near the main entrance to Lytham Hall before it was moved to Ballam Road to make way for the railway station. I have been told that Old Tom, when the council were considering a new road lay-out in the area, was found to be suffering from Dutch elm disease and had it cut down. Either the road scheme did not work or materialise because today, a weedy Young Tom stands where magnificent Old Tom once reigned supreme.

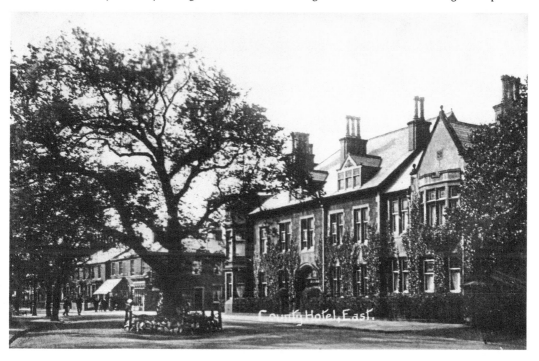

County Hotel, East.

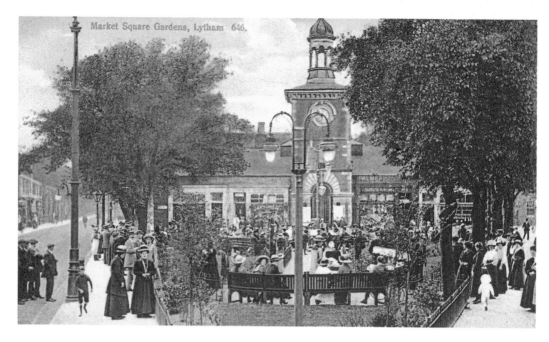

Market House

Near the Market Hotel (now the County Hotel with a celebratory date of 1797–1897 over the entrance) is Market Square. This area was originally the village green with a cross and fish stones where locally caught fish was sold. The Market House was built in 1848 containing twenty-three stalls and became a very popular shopping venue for the next thirty-five years. Lady Eleanor Clifton decided it would be beneficial for the townsfolk to have a clock, so in 1872 she paid to have a tower erected in front of it with a clock. The memorial water fountain installed in 1890 was relocated to Ballam Road to make room for the war memorial.

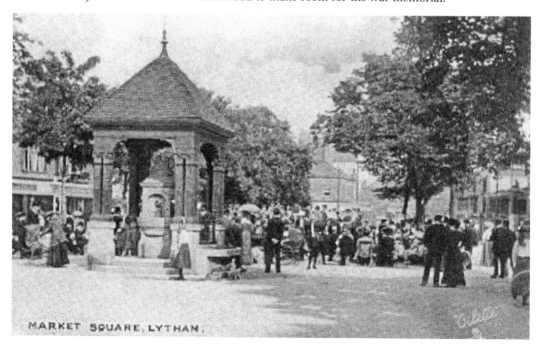

MARKET SQUARE, LYTHAM.

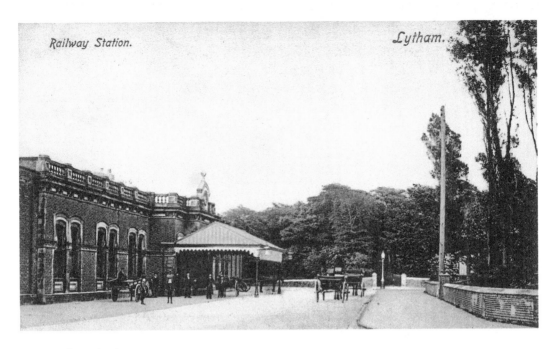

Railway Station. *Lytham.*

Railway Stations

By the Market House and Square is an area known as Hastings Place leading down to Station Square where, when the railway arrived from Blackpool in 1863 a station was built. In 1874 the line was extended to the other station in Station Road, which was then closed to passengers and later demolished, leaving the hotel. Due to cutbacks the new station building was also closed (even though a train can still be caught there) in 1960 and left to become derelict. In 1986 it was restored and opened as the Station Tavern. In the distance alongside Ballam Road is Sparrow Walk wood.

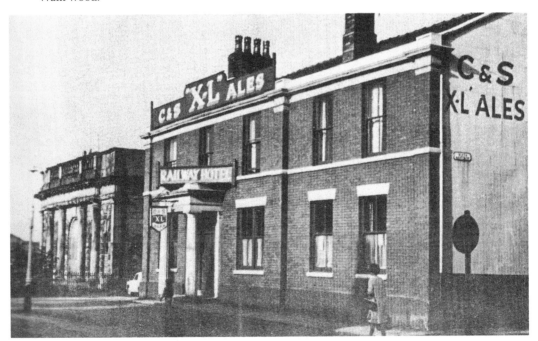

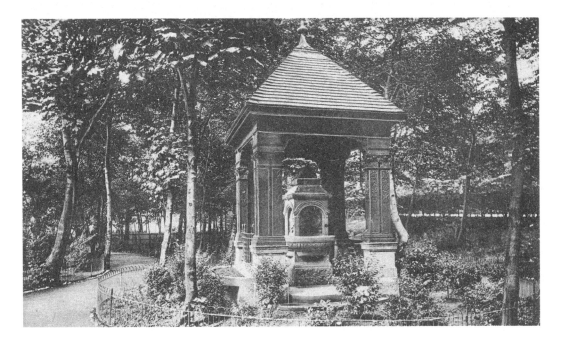

Memorial Fountain

The Memorial Water Fountain in Sparrow Walk wood near the station at the end of Park Street used to be in Market Square but was relocated here to make way for the War Memorial. The Fountain was donated by Lady Eleanor Clifton in memory of her husband who died in 1882, two years after the death of their only son Thomas Henry. Looking back up Park Street to the town centre the Wesleyan Methodists Chapel can be seen on the right which was erected here in 1868 when the one in Bath Street that they had used since 1847 became too small to take the influx of summer visitors.

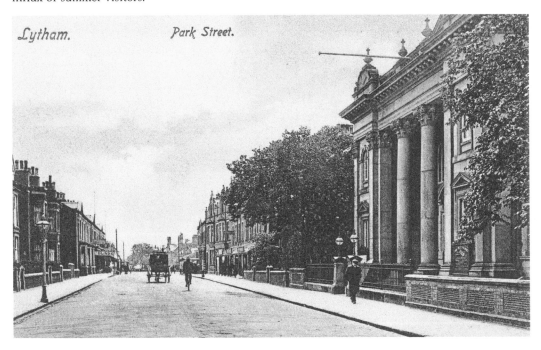

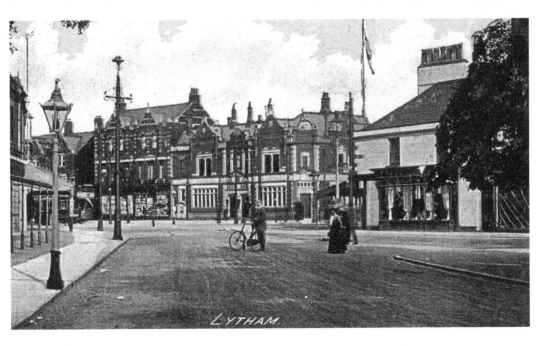

Clifton Square

Here at Clifton Square as seen from Market Square six roads terminate, clockwise, Church Road with Hastings Place, Park Street, Clifton Street, Dicconson Terrace and Henry Street (which used to be called Duck Lane) From outside Stringers shop looking seawards the Pavilion on the pier can be seen. The first low building on the right was originally built in 1899 for the Manchester and County Bank and later the Trustee Savings Bank took it over. It is now used as the Lytham Heritage Centre formed in 1987.

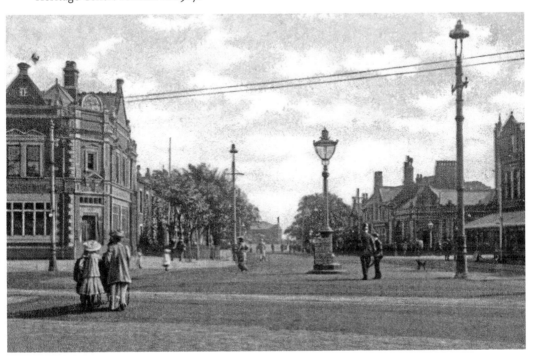

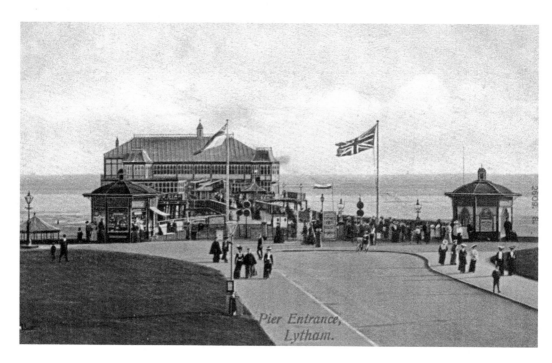

Pier Entrance, Lytham.

The Pier I

From the seaward end of Dicconson Terrace is an expanse of grass running left to right known as Lytham Green on which many functions take place throughout the year. The top postcard picture was obtained from one of the upper rooms in the public baths showing the pier entrance with its kiosks; at one time there was an ornate metal arch over the entrance near the left-hand kiosk with a sign hanging under it saying 'Unmarried?' The lower one shows the kiosks as seen from the West Beach side of the promenade with the paddling pool on the beach and the windmill and lifeboat house on East Beach.

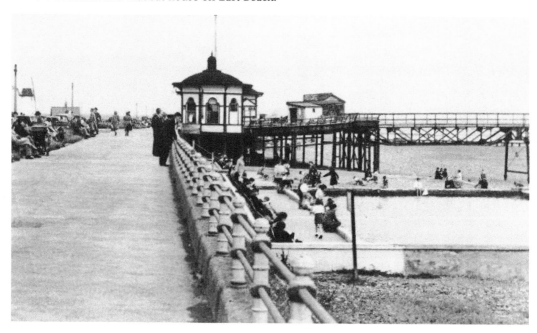

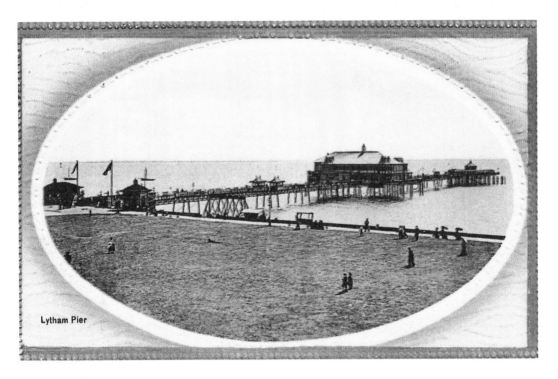

Lytham Pier

The Pier II

The residents of Lytham subscribed to the construction of the pier which was opened by Lady Eleanor Clifton in 1865. The oval picture shows the pier had to be 914 feet in length to reach the shipping lane of the North Channel from Preston so various types of ships including pleasure craft could dock there. Originally there was only a waiting room at the end of the pier but in 1890 a Floral Hall was added, followed by the Pavilion in 1892 which was enlarged in 1901, straddling the whole width of the pier. The lower card shows the disaster of 1903 (more later).

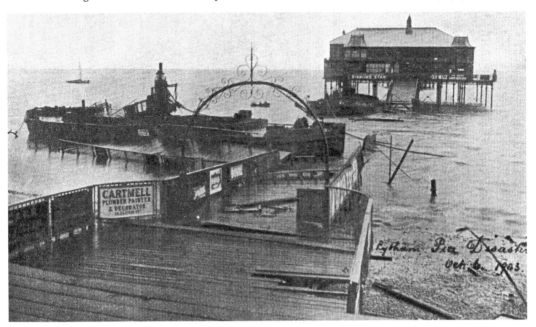

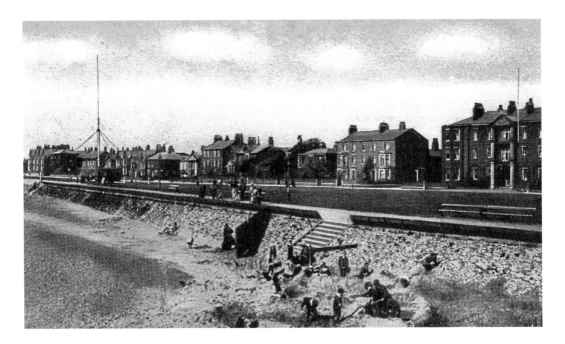

West Beach & Charlie's Mast

Charlie's Mast is situated on West Beach and named after Charlie Townsend (I wonder if it's the same Charlie that is supposed to haunt the Ship Hotel) a guinea trader who reputedly set up the first mast using the shaft of a horse cart with a lamp tied to the top of it to help guide ships into Lytham mud dock. A new mast was erected in 1959 surrounded by a shelter. The lower one shows a very busy beach and promenade scene with the wooden framework of the swings on the left. The notice by the stall says 'TRY our NOTED ICES'.

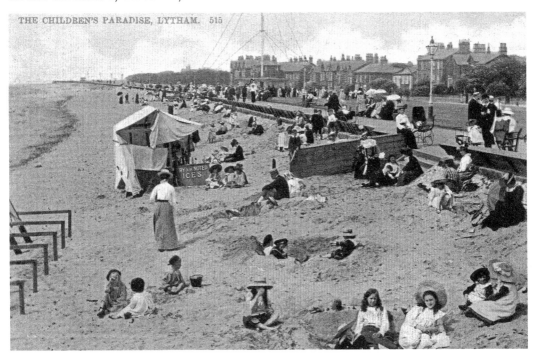

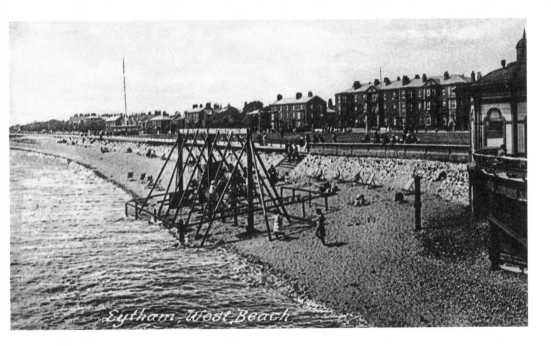

Lytham West Beach

Paddling in the Sea

West Beach as seen from the pier with one of the pier entrance kiosks just visible on the right; next to it on the other side of the promenade and green is the Clifton Arms Hotel. Charlie's Mast in the distance and swings on the beach can be seen, the paddling pool and sand pit are yet to be installed. The lower postcard shows children and adults enjoying themselves paddling in the sea with ships in the distance heading to and from the various docks along the coast.

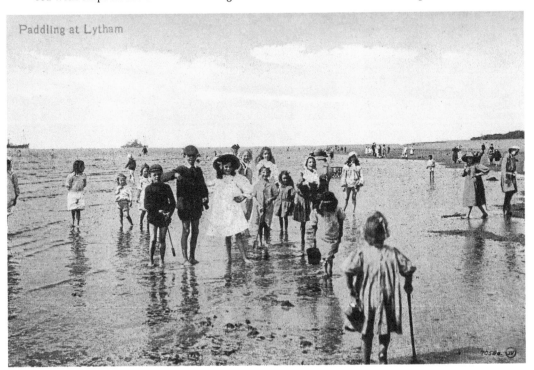

Paddling at Lytham

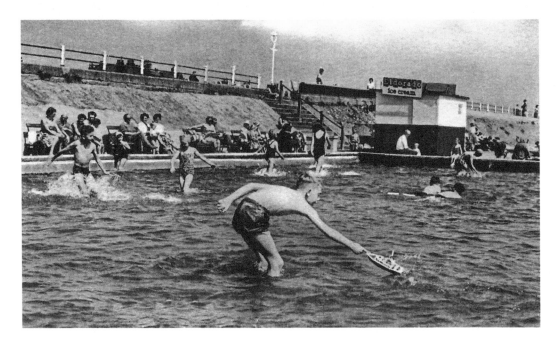

The Paddling Pool

Taken at slightly different periods in time these two postcards show the pool which was very popular in its heyday and children playing with their toy boats; probably not for much longer though, because when a channel was dredged from Preston docks straight out to the Irish Sea making the docks available to the larger ships via this route, the North Channel which they had used previously silted up, causing the beach level to rise with mud which was soon covered by Spartina grass spreading along the coast from Preston.

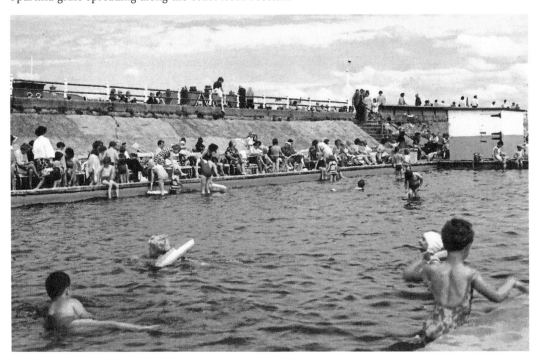

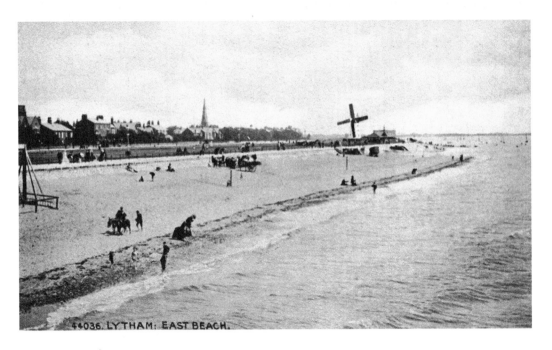

44036. LYTHAM: EAST BEACH.

East Beach

Looking at Lytham's East Beach from the pier. The first view shows the swings and children riding on the donkeys with St John's Church, the windmill and the old lifeboat house and possibly its slipway down to the beach in the background. The lower picture with one of the kiosks by the entrance on the left shows a quieter day on the beach, the donkeys having a well-earned rest while the promenade walk is slightly busier.

EAST BEACH, LYTHAM. 502

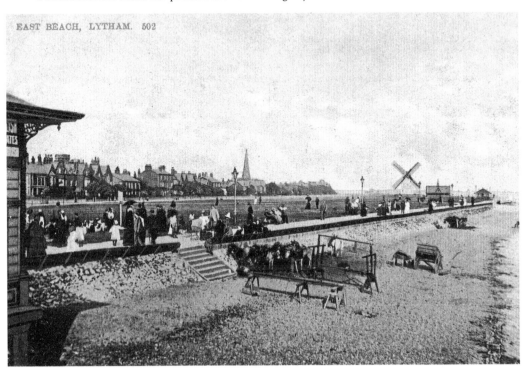

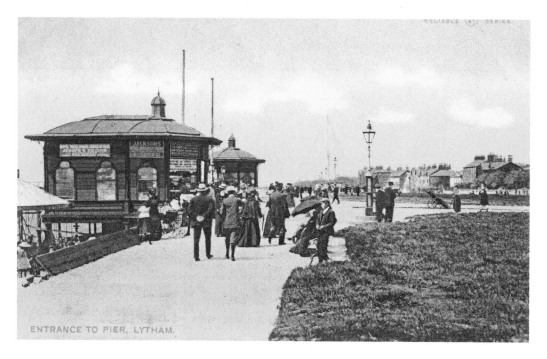

ENTRANCE TO PIER, LYTHAM.

Disasters

From East Beach looking back to the pier which over the years had its fair share of disasters: firstly, during a storm two sand barges broke loose from their moorings, crashing into it and slicing it in two in 1903. In 1927 the Pavilion, that had been used for many things and was now a cinema having been converted from an ice rink, caught fire and was not replaced. By 1938 the Floral Hall had become unfashionable so it and the pier were closed down and left to become a derelict eyesore on the sea front. The windmill was destroyed by fire in 1919 and rebuilt.

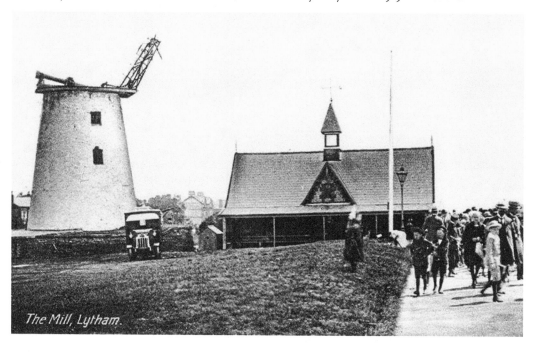

The Mill, Lytham.

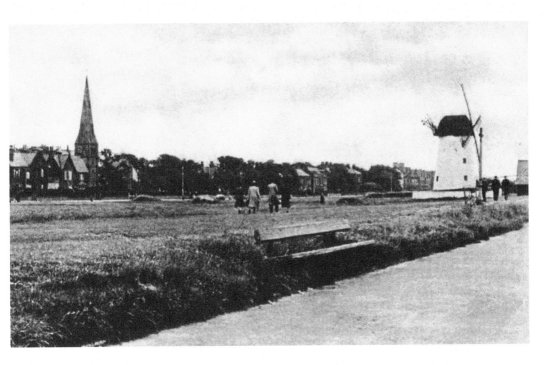

Lytham Windmill

According to maps and records the present windmill on East Beach was built on the site of an earlier one in 1809; originally it had a base diameter of 50 feet and stood 50 feet high. The fantail was added in 1870 to automatically turn the sails into the wind which at the time measured 80 feet in length from tip to tip; they are now only 56 feet. In 1909 a small boy on a day visit from Manchester could not resist the temptation of trying to hang onto them and was hoisted up to the top, where, losing his nerve, he let go and fell to his death.

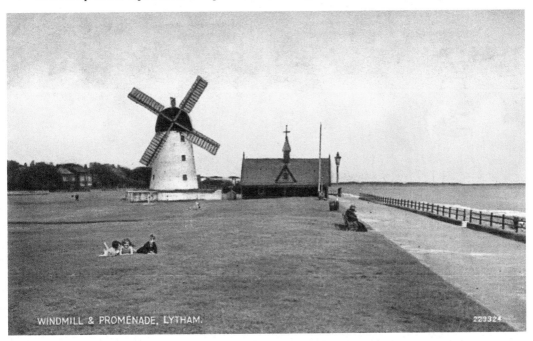

WINDMILL & PROMENADE, LYTHAM. 223324

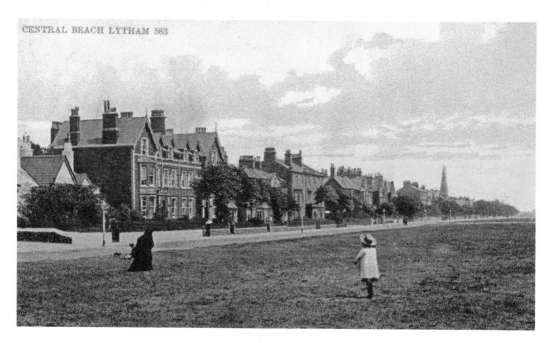

Lytham Green

The white cottage on the left has a history going back over 200 years when it was one of only a few cottages on the sea front and was surrounded by a wall built with cobblestones from the beach and is thought to have been a hunting lodge on the Clifton Estate. In the 1880s it was occupied by William Rawstorne and his wife who had a pet dog which she was very fond of. In the garden there is a headstone to a grave which says, 'Here lies faithful Dum Dum, died January 1815 aged 14 years'. According to the owner it is still there.

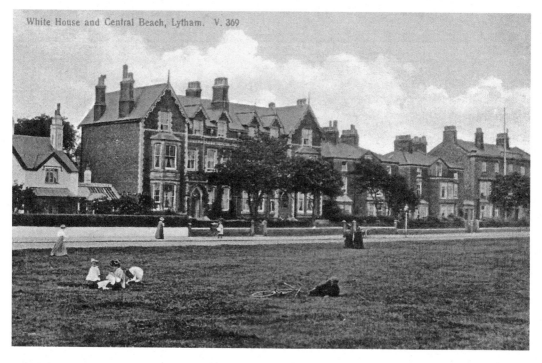

White House and Central Beach, Lytham. V. 369

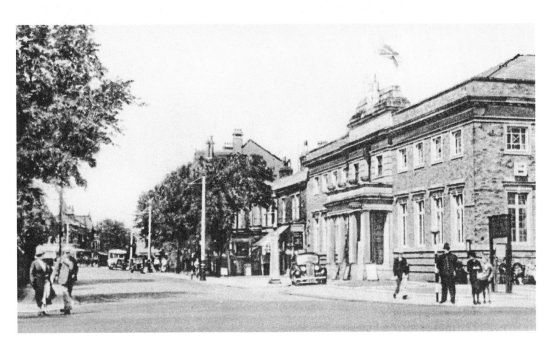

Lytham Baths

Public baths existed on Central Beach during 1840 and 1860 when a contract was granted for new baths on the corner of Dicconson Terrace and Central Beach. The first section, which included the Assembly Rooms (the only part still standing) and Yacht Club, with its high square tower and entrance was completed in 1862; the baths section and offices were finished in 1863. In 1926 the baths and offices were demolished to make way for the Lytham Remedial Baths in 1928, these being the only baths in the north at the time to use hot and cold sea water to treat ailments like rheumatism, sciatica and gout.

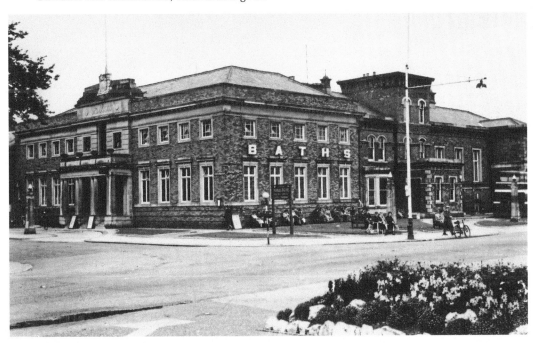

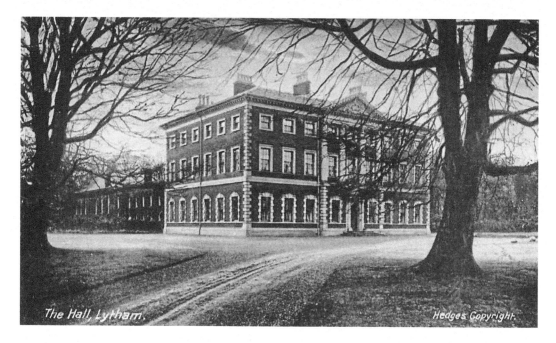

The Hall, Lytham. Hedges Copyright.

Lytham Hall and Main Entrance

Much has been written about the hall itself, how the Cliftons acquired it in 1606 and that Thomas Clifton built the present hall on or near the site of the old priory between 1757 and 1764. Various tales of hauntings have been handed down over the years such as the Long Gallery being haunted by the White Lady and heavy footsteps and dragging chains have been heard in the Duke of Norfolk's room with the door being suddenly flung open. During some conversion work many workers refused to go on the top floor of the south wing. A phantom dog is said to roam the grounds.

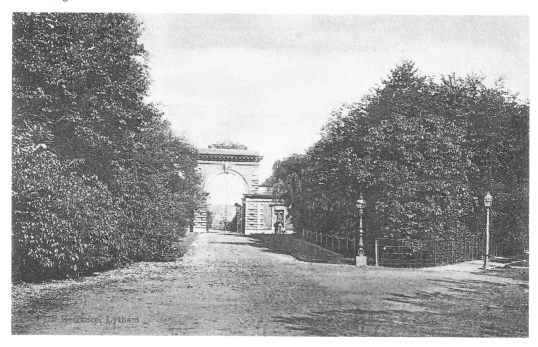

The Entrance, Lytham

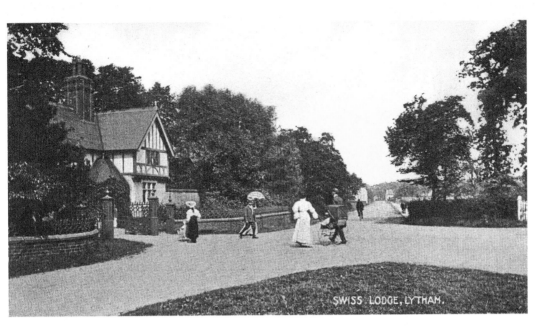

SWISS LODGE, LYTHAM.

Green Drive

Another entrance to Lytham Hall estate is Swiss Cottage at the end of Green Drive off Saltcoates Road which runs through a wood crossing Ballam Road past Watchwood Lodge (not to be mistaken for Witchwood) and on to the hall. Witchwood is a wood and footpath running from Lytham railway station to Blackpool Road, getting its name from a favourite horse of the Cliftons called Witch, following an accident which was put down, and whether buried in the wood is uncertain but a monument was placed there. Columns of stones at some of the entrances to the wood once formed part of the portico entrance of the railway station.

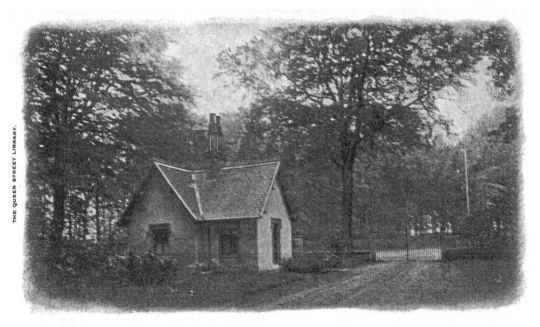

WATCHWOOD LODGE, LYTHAM.

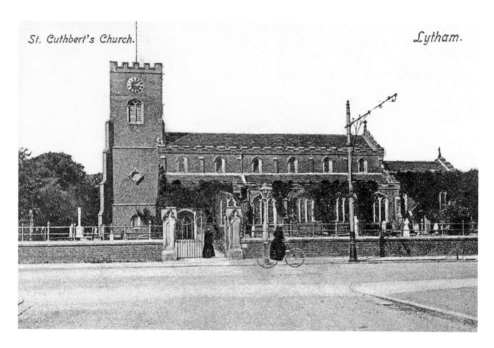

St Cuthbert's Church

There has been a church at Lytham since 1199. The original was made with shingle from the beach which was later replaced by a stone one; when this started to collapse in 1760 it was replaced by a low cobbled-stone building with walls 3 feet thick and five windows including one at the east end. As the population increased, especially in the summer months, a larger place of worship was required so a foundation stone was laid by Thomas Clifton on 20 March 1834 on the site of the church we see today. It was extended in 1872, 1882 and 1909; the lower picture is of the inside.

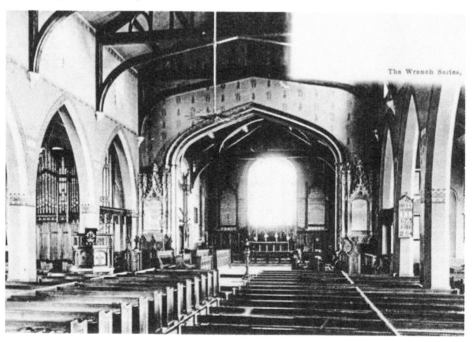

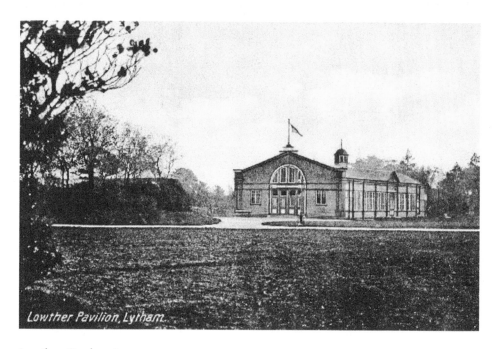

Lowther Pavilion, Lytham.

Lowther Gardens I

There are four entrances to Lowther Gardens, the one on the corner of West Beach and Lowther Terrace and the one diagonally opposite on the corner of Church Road and Woodville Terrace having three ornate cast-iron archways with Lowther Garden signs on them. It was created on a tract of poor agricultural land on the western side of the town known as Hungry Moor and donated by Squire Clifton for recreational purposes in honour of his wife and in memory of her father who died in 1868, calling it Lowther Gardens because Lowther was their family name. The gardens were handed over to the council in 1905.

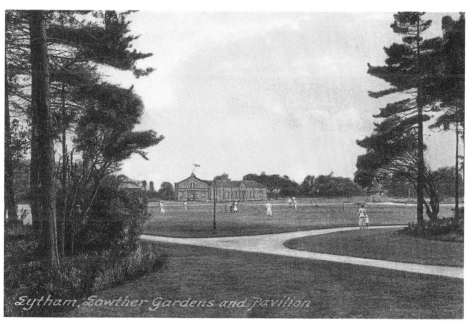

Lytham, Lowther Gardens and Pavilion

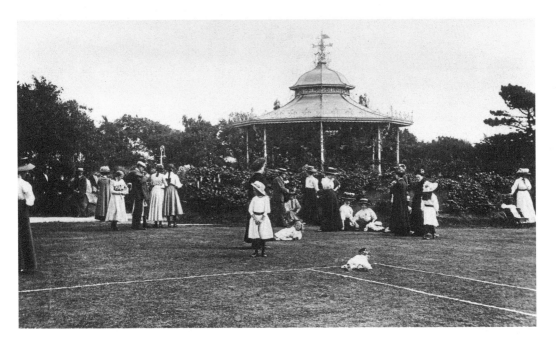

Lowther Gardens II

The first Lowther pavilion was erected in 1922 with some modification taking place in 1950 when a much-needed tea room was added to the side. In 1976 the future of the pavilion was in doubt when due to a freak car accident it was found that the steel girders which formed the framework around which it was built were rotting away and needed replacing. Luck, however, was on its side when in 1977 the theatre in neighbouring St Annes was destroyed by fire and its Operatic Society relocated to Lowther, so securing its future.

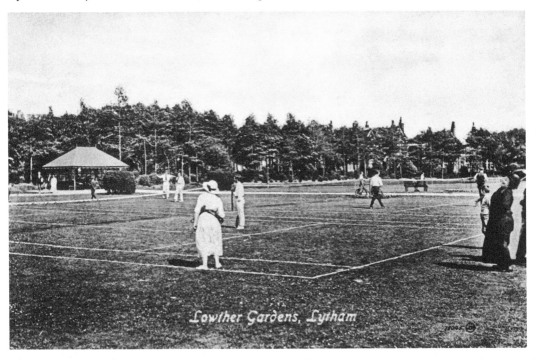

Lowther Gardens, Lytham

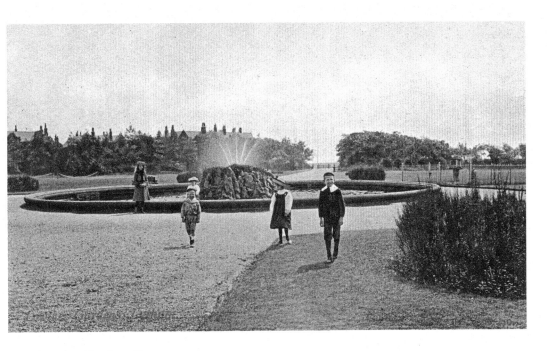

Lowther Gardens III

In 1982 the pavilion was completely rebuilt and extended, apart from the roof which was altered at a later date. Near the pavilion stood an ornate bandstand and tennis court. The central pool and fountain in the gardens were refurbished and the monument to a traditional shrimper was unveiled in 2003. Many shrimpers lost their lives along the sometimes treacherous coast here as the postcard sent by Mrs Spencer in 1909 to her sister in Accrington shows the wreckage of a typical shrimping boat called *The Little Nellie* in which two fishermen lost their lives.

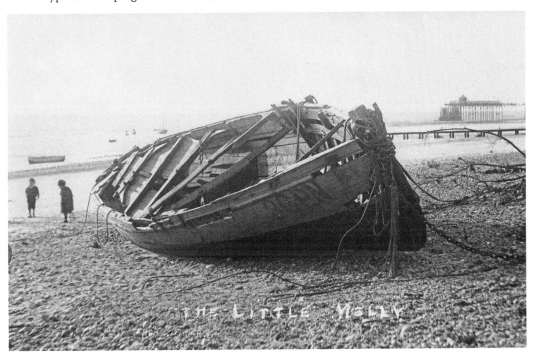

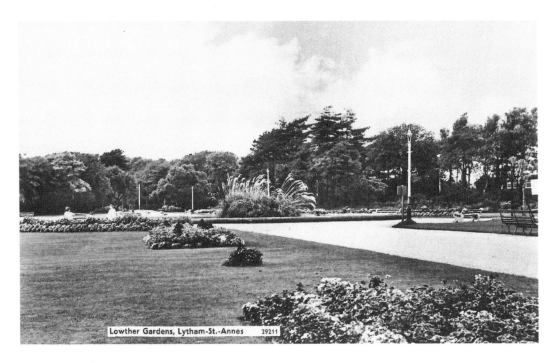

Lowther Gardens, Lytham-St.-Annes 29211

Lowther Gardens IV

The rose gardens near the putting green on the side of the gardens which runs parallel with Church Road were replanted with 1,100 new bushes and fifteen new seating areas provided in 2002. At the time of writing in 2016 it was reported that the theatre was to undergo a five-year major refurbishment starting in the near future to bring the theatre and café into the twenty-first century and, when the money allows a bright glass-roofed entrance hall containing a booking area.

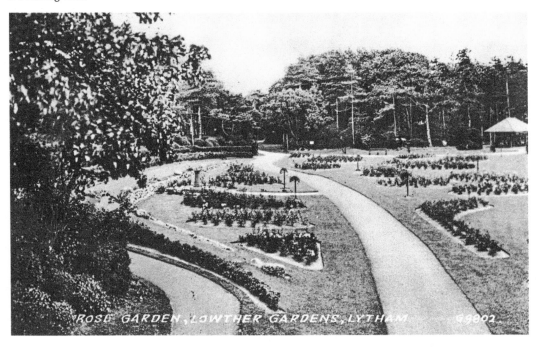

ROSE GARDEN, LOWTHER GARDENS, LYTHAM 69902

FAIRHAVEN & ANSDELL

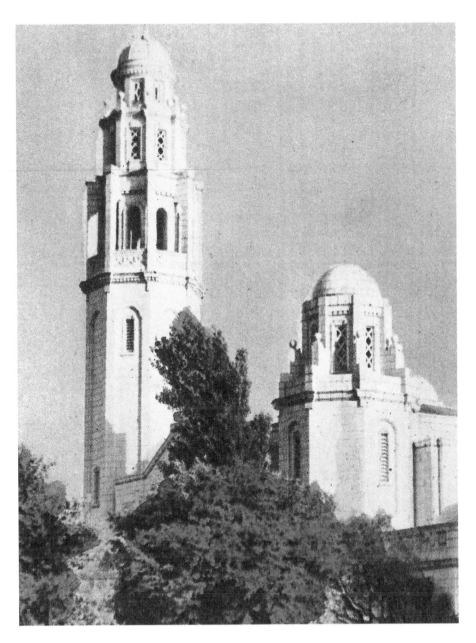

The White Church

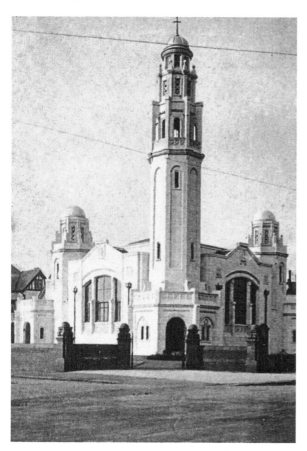

White Church/Baptist Church

The officially called Fairhaven United Reformed Church (known locally as the White Church) began life with a meeting in 1899 at which it was decided to build a new church at Fairhaven of a distinctive architectural design, so a Byzantine style was adopted for the outside. The church was opened on 7 October 1912 and could be seen from Southport. The Baptist church on the junction of Ansdell Road and Blackpool Road was established in 1908, replacing a small corrugated-sheet building erected in 1906. It is now called the Well Church and is attended by families from all walks of life.

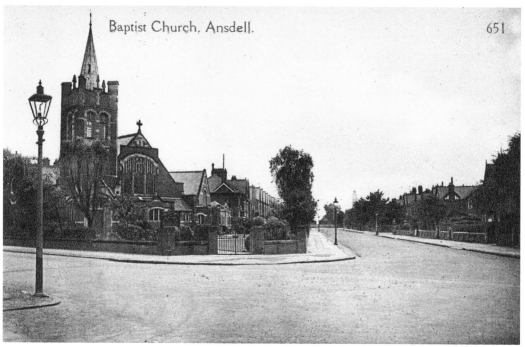

Baptist Church, Ansdell. 651

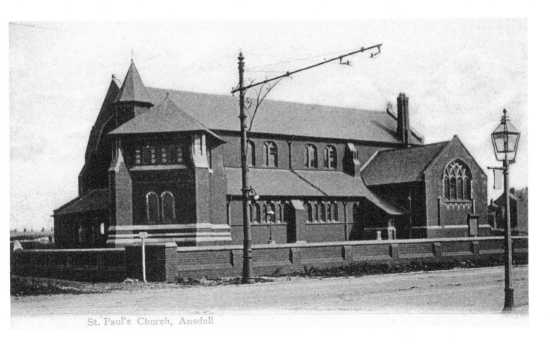

St. Paul's Church, Ansdell

St Paul's Church

St Paul's Church of England church is situated on South Clifton Drive at its junction with Lake Road North and sits in pleasant grounds a short stroll away from the sea front and Fairhaven Lake. The foundation stone was laid on the 25 January 1902 and consecrated on 29 January 1904. It had a mission church on Commonside Road in Ansdell as seen in the postcard below which was destroyed by fire in the early 1970s and demolished, leaving an empty space until the library was built on the site in 1990.

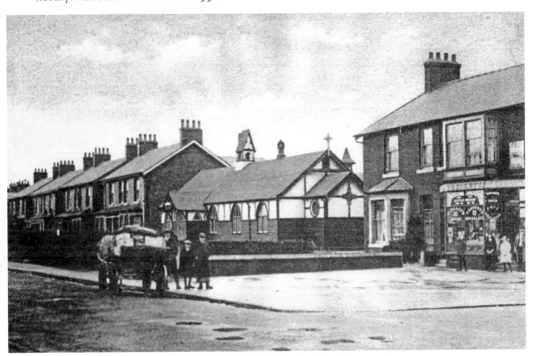

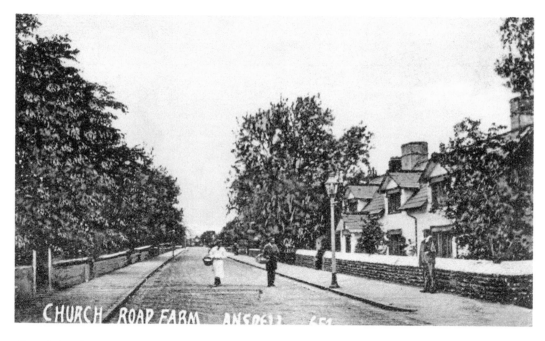

Church Road Farm

Ansdell is the adopted name for an expanse of land that lay on the seaward side of Lytham Common. Richard Ansdell, a renowned artist born in Liverpool, got a liking for the area when he was commissioned by Squire Thomas Clifton in 1844 and built a house there (Starr Hills) in 1860 near the sea front on empty barren land leased from the Clifton Estates. The area became known as Ansdell's land which retained the name after he sold the house and moved away in 1873. Ansdell was dotted with small cottages and farms such as Church Road Farm which despite its name is on Commonside Road.

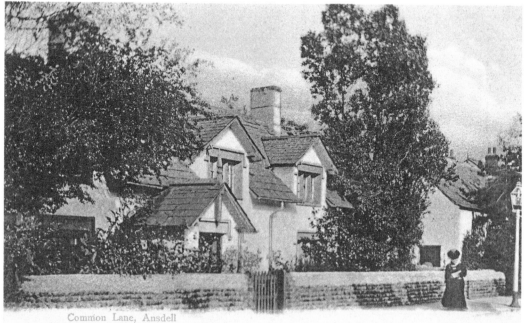

Common Lane, Ansdell

ANSDELL.

Commonside Farm and Cottage

After Dr J. R. Litt inspected the cottages in the area in 1945, he decided they were unfit for human habitation and recommended they be demolished. In an article in the local paper in 1948 they were still in existence and inhabited because Mrs Garside who had lived there for sixty-five years defied anyone to find a spot of damp in her home, but the council were determined to get rid of them for so-called road improvements. Bungalows now occupy the site. Commonside Farm can be seen at the back of the top postcard.

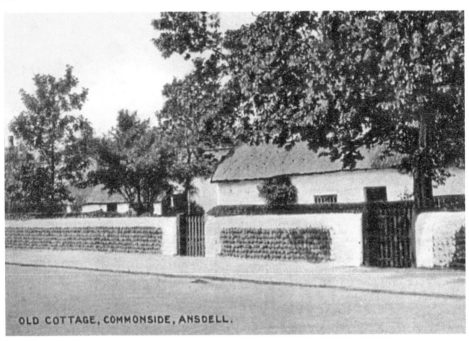

OLD COTTAGE, COMMONSIDE, ANSDELL.

Woodlands Road Cross Roads

The cottages and farms tended to be built slightly inland, away from what could be a stormy, windy coastline in places like Commonside. At the crossroads formed by its junction with Woodlands Road was St Paul's Mission Church, opposite which stood Tambourine Cottages, eight terraced cottages, now Grade II-listed, built in the second half of the nineteenth century with cobbled-stone walls at the front. At the far end of Commonside where it joins Gordon Road stood the cruck-style thatched cottages mentioned on the previous page occupied mainly by Clifton Estate workers and fishermen.

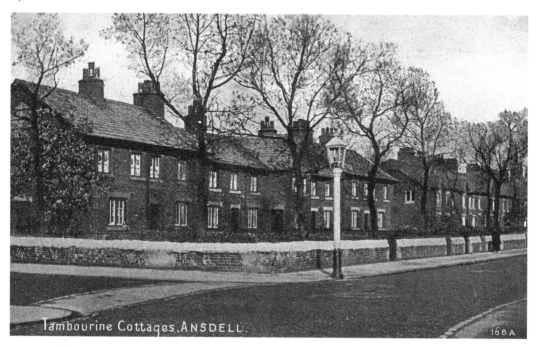

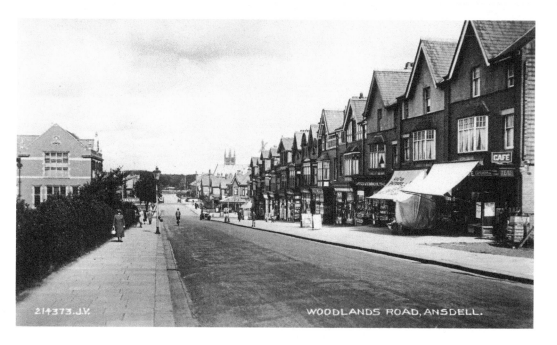

Woodlands Road

From Blackpool Road through Ansdell village to South Clifton Drive runs Woodlands Road. The first image shows it running inland from the top of the railway bridge with the station underneath, past the Ansdell institute and Social Club on the left and the tower of St Joseph's Church in the background. The bottom view is looking up Woodlands Road from South Clifton Drive. Fairhaven Methodist church on the left was founded in 1909 and is on the site of a smaller chapel. On the right with the black and white (magpie) apexes is what was the Rossendale Hotel, now a rest home of the same name.

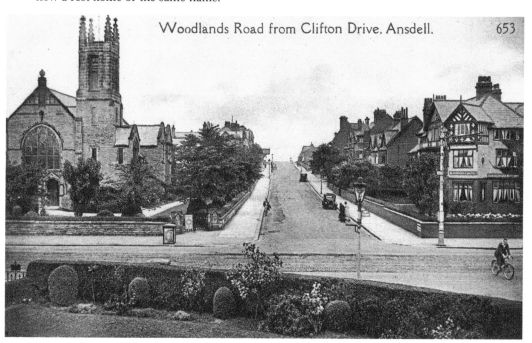

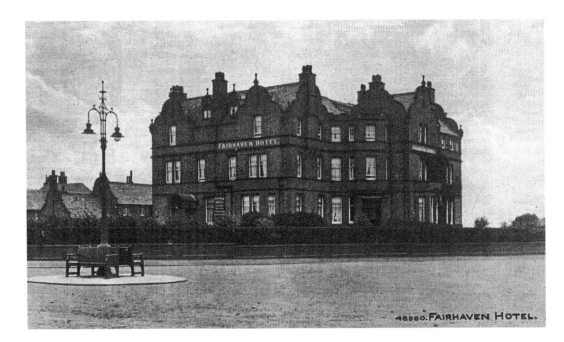

48980. FAIRHAVEN HOTEL.

Fairhaven Hotel

There was a stretch of land between Ansdell and the coast which became known as Fairhaven when the now-wealthy businessmen started to come and build there on land leased from the Clifton Estates. Hotels were also built and one was the Fairhaven Hotel with its impressive, unbroken views over Granny's Bay to the Welsh hills and the Irish Sea beyond. It was demolished in 1976 and replaced with a nondescript smaller version public house with the same name, its panoramic sea views being destroyed by a block of apartments. The lower card shows the slope down to Granny's Bay.

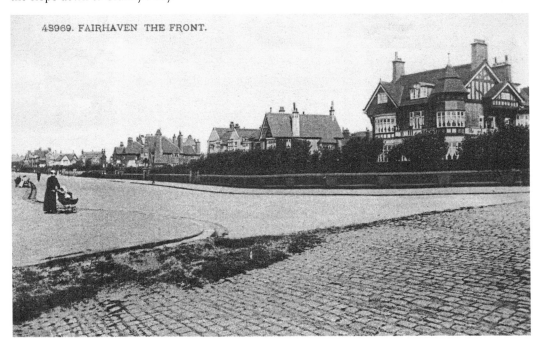

48969. FAIRHAVEN THE FRONT.

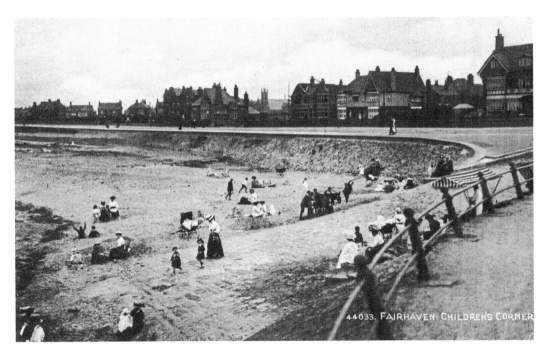

44033. FAIRHAVEN, CHILDREN'S CORNER

Children's Corner, Granny's Bay

The bottom postcard on the previous page shows the cobbled slope down to the beach used by donkeys and fishermen which created a corner on the beach that became known as the children's corner. The bay is believed to have been a favourite place of one of the Clifton ladies and if she ever went missing from the hall they assumed she had gone to Granny's Bay where as a grandmother she used to take her grandchildren to play. Both postcards show adults and children playing in the sandy corner.

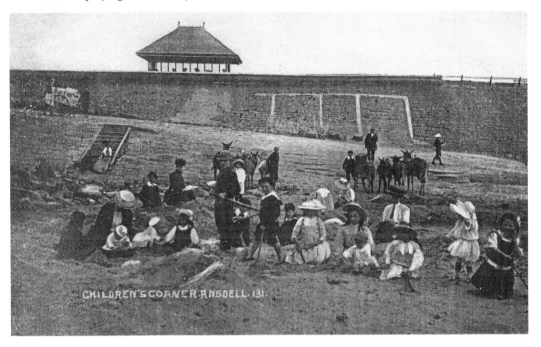

CHILDREN'S CORNER. ANSDELL. 131.

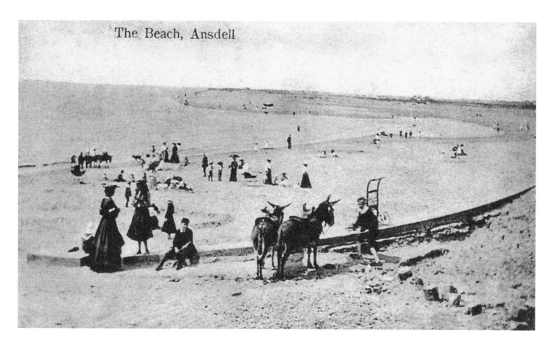

The Beach, Ansdell

Granny's Bay

The top card shows the long sweep of Granny's Bay as seen from the Inner Promenade looking over what was to be developed as Fairhaven Lake, to the Irish Sea. The bottom postcard view, back to where roughly the top one was taken, is from the Outer Promenade round the back of Fairhaven Lake, both showing a nice sandy beach before the Spartina grass took over. The main occupations before tourism were either agriculture or fishing. Men fished offshore mainly for shrimps, which Lytham became famous for, while the women could regularly be seen paddling in the bay here or at Horsebank gathering cockles.

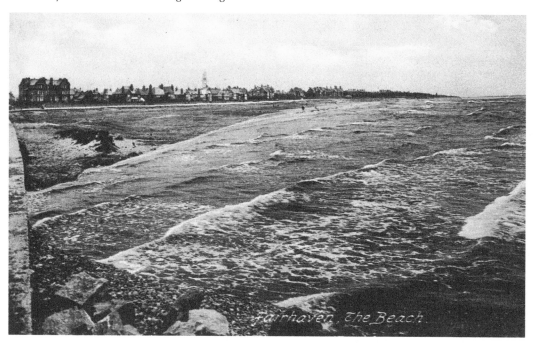

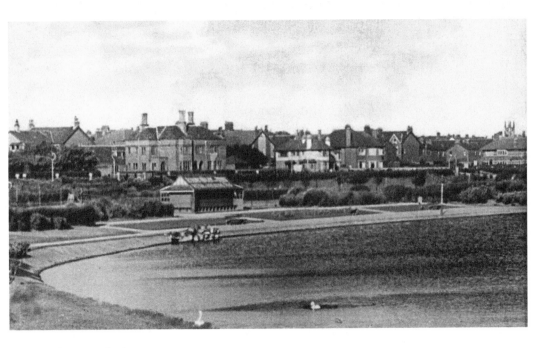

Fairhaven Lake I

The top view is of the northern end of Fairhaven Lake from the Outer Promenade with the tennis court pavilion on the far side. The lake was built between two pebble and shingle banks (stannars), a safe haven during stormy weather for the fishermen's boats. The lake created was 1,200 metres long and 400 metres wide with a depth of 1.2 metres at the most. The swans are probably ancestors of those there today and the one on the bank appears to be keeping guard. The coloured postcard is of the southern end which is mainly the business end with its tea rooms and where boats of various styles could be hired.

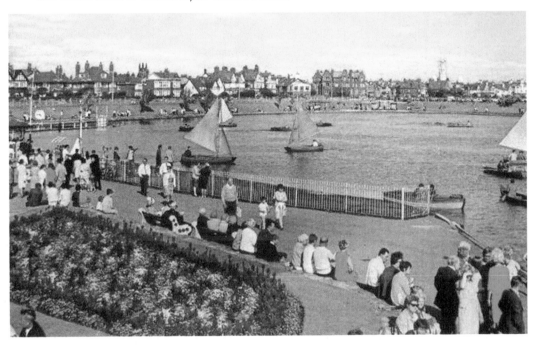

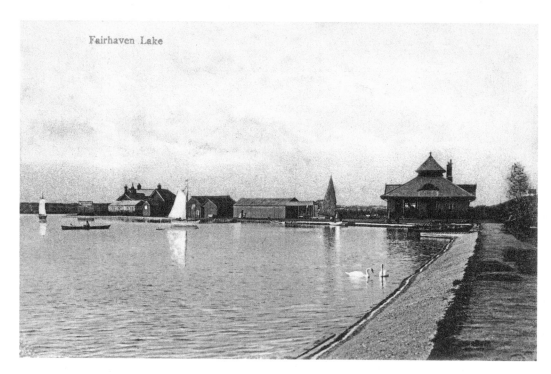

Fairhaven Lake

Fairhaven Lake II

Besides the tea rooms and boat-hire facilities at the commercial end of the Fairhavenlake, tennis courts and bowling greens were also provided. Also because the area is so abundant with wild birds, making it a magnet for birdwatchers, the RSPB has set up a discovery centre there. During the Second World War the townsfolk raised enough funds to buy a Spitfire aeroplane to help the war effort. It was shot down off the Devon coast in 1942. On 14 August 2012 a full-sized model of a Spitfire memorial was unveiled in the grounds of Fairhaven Lake in honour of this and the pilots who lost their lives flying them.

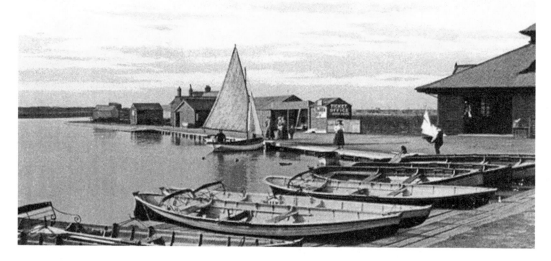

Fairhaven Lake, nr. St. Anne's-on-Sea.

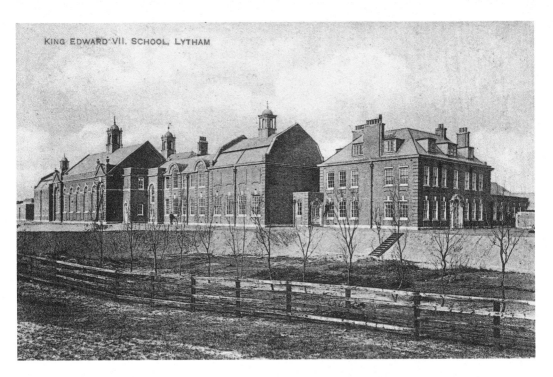

King Edward VII School

Besides the railway there are three roads out of Fairhaven and Ansdell. Firstly, the Inner Promenade that runs behind Edward VII (opened in 1908) and next door Queen Mary's (opened in 1930) schools, joining up with the South Promenade Road at Cartmell Road, St Annes. Secondly, Clifton Drive South that runs past the front of the schools built on the boundary of Lytham and St Annes. King Edward's merged with Queen Mary's becoming KEQMS School in 1997 which in turn merged with Arnold School from Blackpool in 2012. Queen Mary's complex was sold and converted into apartments.

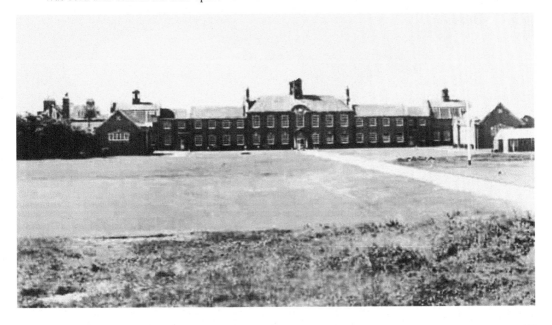

BLACKPOOL ROAD.

St Joseph's Church

The third road out is Blackpool Road on which stands St Joseph's Church. The first picture shows a swan-necked water pipe with a cobbled area in front of it (a pipe like this in Fleetwood town centre was where residents paid to have containers filled with fresh water), so maybe the residents of Ansdell did the same until mains water was laid from Ballam in 1911. St Joseph's Roman Catholic Church occupies a commanding position on the corner of Blackpool Road and Woodlands Road whose foundation stone was laid in 1909 on the site of a temporary chapel and has a presbytery attached.

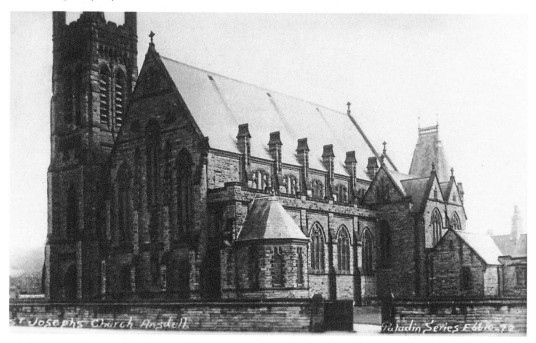

St Joseph's Church Ansdell Paladin Series E66 16.72

Regent Road/Avenue

Carrying on along Blackpool Road, out of Ansdell to where just before it joins up with the old Heyhouses Lane near what was the Trawl boat Inn, Regents Road/Avenue is passed on the right. As Regents Road it was another entrance to Lytham Hall estate but now, having its name changed to Regent Avenue, it is the entrance to Park Cemetery and Crematorium. The first picture shows what it was like with Boardman's thatched farm on the left and the keeper's cottage in the distance on the right. The lower picture is as L.S. Lowry saw it in the 1920s with the same buildings.

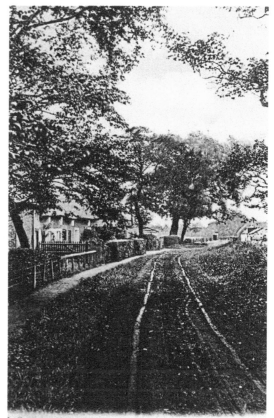

Country Lane, Ansdell.

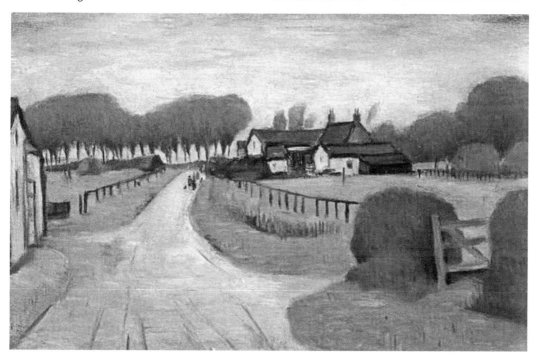

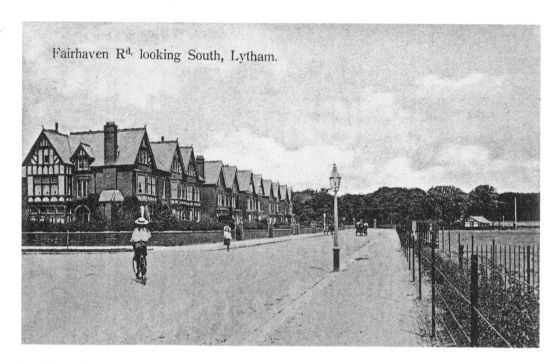

Fairhaven R^{d.} looking South, Lytham.

Roads in Fairhaven

Leaving Lytham for Fairhaven and Ansdell, the first road we come to is Fairhaven Road as seen in the top picture at its junction with Clifton Drive before it was extended across the field on the right to join up with West Beach, Lytham. Church Road and an entrance to the Lytham Hall Estates can be seen in the background. The lower postcard shows houses with panoramic sea views to the right on Ansdell Road South, which runs between Clifton Drive and Granny's Bay with the prominent White Church on the right.

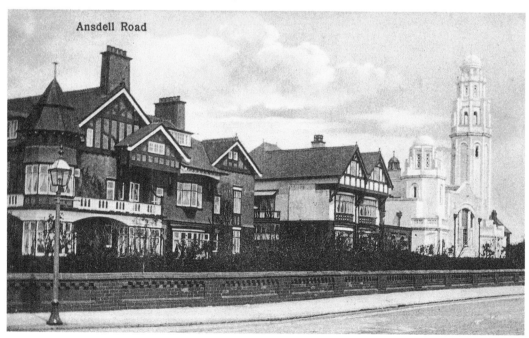

Ansdell Road

ST ANNES

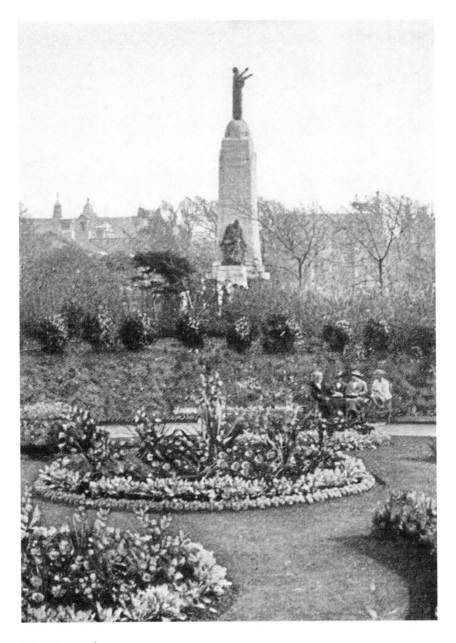

War Memorial

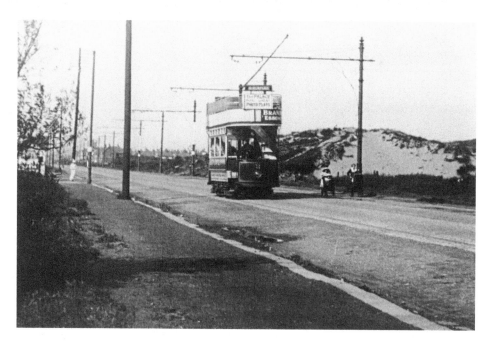

Arriving in St Annes

Two ways of arriving in St Annes were either by the gas-driven tram-followed by the electric-driven tram that came through the town centre travelling from Blackpool to Lytham and vice versa as shown in the top picture. This particular tram is travelling through the sand dunes; the problem of this was the drifting sand in high winds which filled the tracks and could cause a derailment so gangs of men were regularly employed cleaning them out. Or by train, the lower picture shows the station where the train stopped.

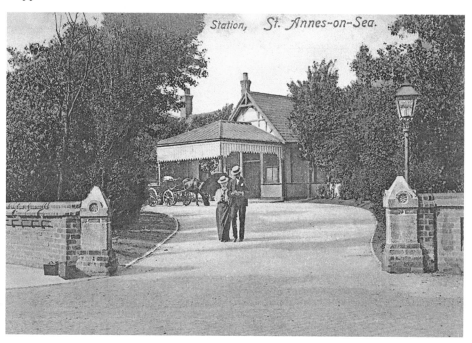

Station, St. Annes-on-Sea.

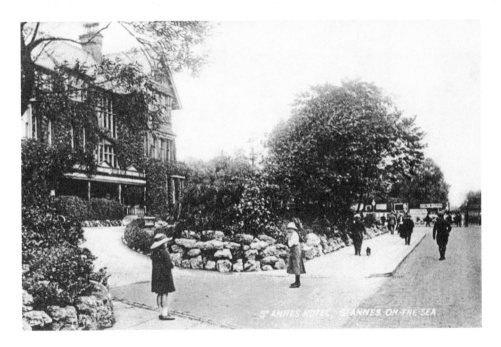

St Annes Hotel

The first building Elijah Hargreaves, who envisaged a new town on the coast with the help of the St Annes Land & Building Co., built was the St Annes Hotel which opened in 1876. The hotel also acted as the clubhouse for the Lytham and St Annes Golf Club whose first tee was on the other side of the railway tracks near the station. The trees and shrubs on the left of the lower picture hid the bowling green (now shops) behind which was a tennis court (now a multi-storey car park) until the hotel was demolished in 1985 to be replaced by a public house.

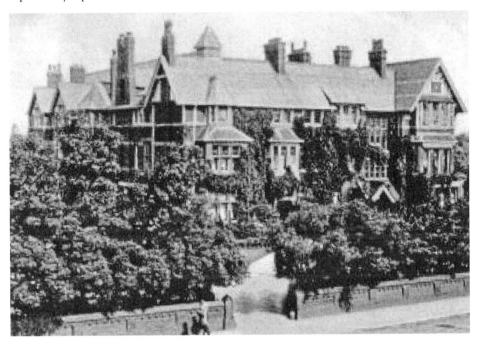

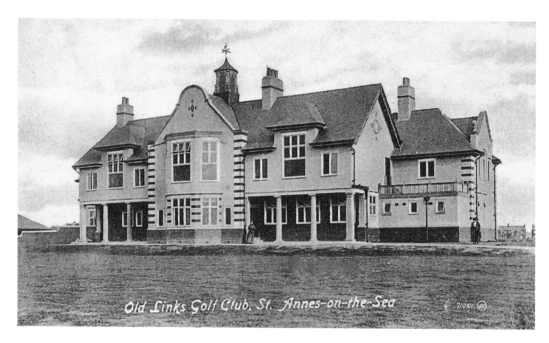

Old Links Golf Club

Lytham and St Annes Golf Club was founded in 1886 near the St Annes Hotel; it relocated to its present site in 1897 becoming a club whose entrance fees the local business people could ill afford when they reached 5 guineas, so a group of men decided to re-establish the old links course by the station, calling it the St Annes Old Links Course in 1901, with an entrance fee of 1 guinea. Due to housing encroachment, the course ended up at its present site on Highbury Road where a championship-quality course in the barren wind-swept sand dunes and wild grass was created.

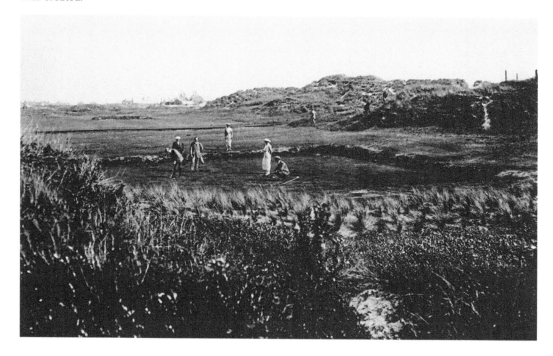

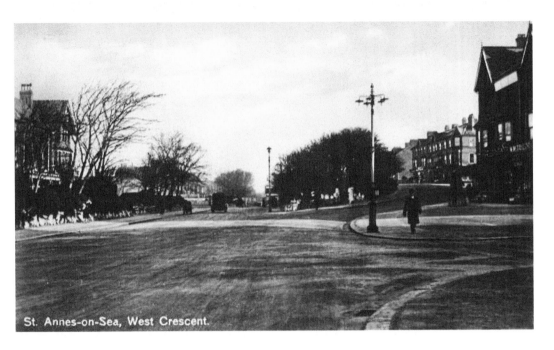

St. Annes-on-Sea, West Crescent.

The Crescent I

Once called Daisy Lane, St Annes Road East and West crossed the railway line via a level crossing near the station. For safety reasons it was diverted over a bridge running parallel with it and which became known as The Crescent. The top card shows this from the town side and the bottom one shows an early view looking inland from the top with St Annes Chapel of Ease and its small spire in the centre distance, its mother church being St Cuthbert's in Lytham. The houses on the right are in St David's Road South.

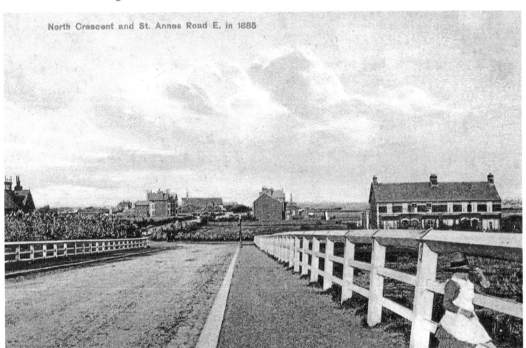

North Crescent and St. Annes Road E. in 1885

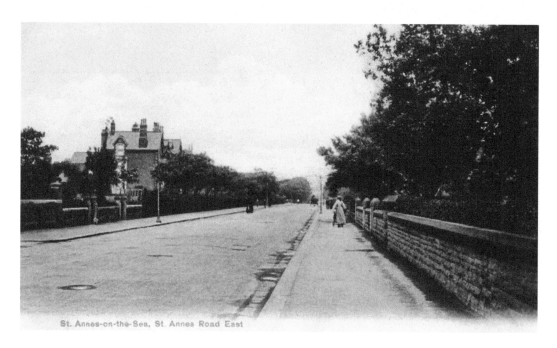

St. Annes-on-the-Sea, St. Annes Road East

St Annes Road East

In the distance on St Annes Road East are the crossroads where it meets Church Road and onwards to the junction at Heyhouses Lane where the original school stood. Along this long, straight road, according to my sand-grown friend Wally Stone, there were two roadside markers exactly one mile apart. At the crossroads at Church Road stand St Annes Parish Church, the new Heyhouses School and Beauclerk Gardens opened in 1924 on land given by the Cliftons so the locals would have a place to play and relax. In 1961 an earthen-ware pot full of coins dating from 1550 and 1644 was discovered there.

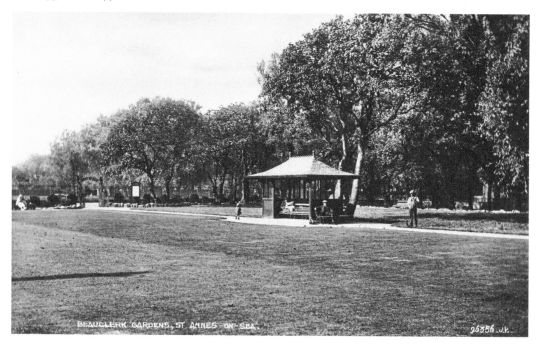

BEAUCLERK GARDENS, ST ANNES-ON-SEA.

96856 J.V.

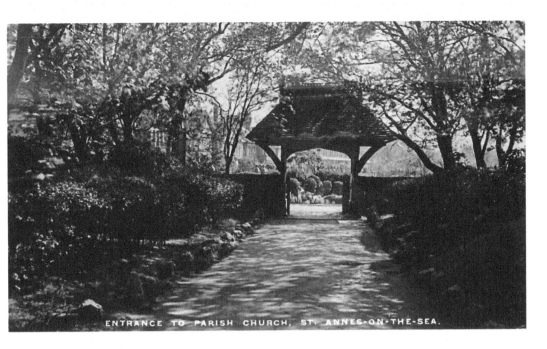

ENTRANCE TO PARISH CHURCH, ST. ANNES-ON-THE-SEA.

St Annes Church

The present lychgate on one of the four entrances to the church grounds originally stood on the corner of Heyhouses Road and Church Road when a Chapel of Ease was built and paid for by Lady Eleanor Clifton in 1874 on land donated by her husband where the locals could worship, in preference to them using the Trawl Boat Inn, the mother church being St Cuthbert's at Lytham. It became a parish in its own right in 1877. The tower was added in 1890 as was a peal of eight bells donated by Lady Eleanor Clifton in memory of her family.

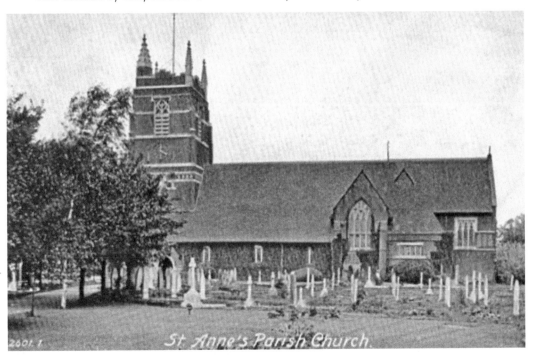

St Anne's Parish Church.

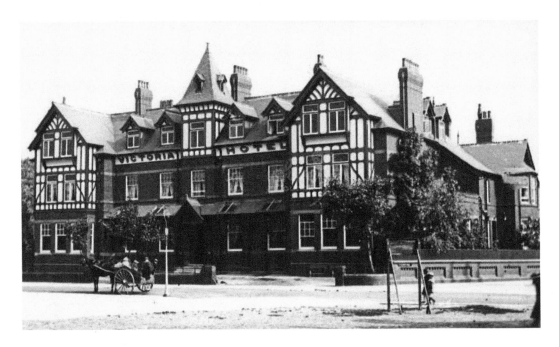

Victoria Hotel

The Victoria Hotel was built in around 1897 on what was then called Commonside Lane (now called Church Road). At the rear of the hotel (which never had any guests) were stables which later became a riding school until the 1980s. Plans to demolish the hotel replacing it with a block of apartments were put forward in 2010, but due to a public outcry and a 700-strong petition the local council rejected it. The lower picture shows the bottom end of St Albans Road where it joins Church Road by the Church Road Methodists church whose foundation stone was laid in 1904. The area became popular with shoppers because of the individuality of the shops and continues to be so today.

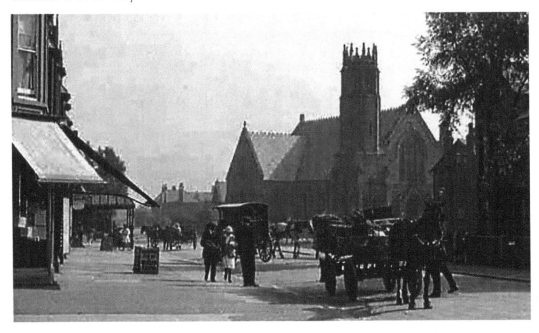

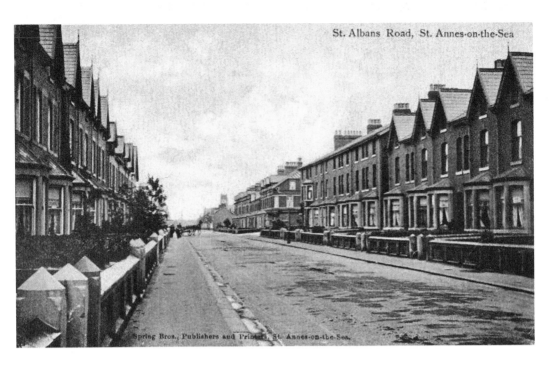

Spring Bros., Publishers and Printers, St. Annes-on-the-Sea.

St Alban's Road

Lower down on the right in the top picture there appears to be an area of spare land on which a car park, the St Annes Pensioners Hall and a YMCA centre, which was opened by HRH the Duchess of Gloucester in 2002, were constructed, the postcard was published Spring Bros whose shop can be seen in St Annes Square on page 63. The coloured postcard shows St Albans Road from near where St Patricks (reputedly the longest road in St Annes) crosses it.

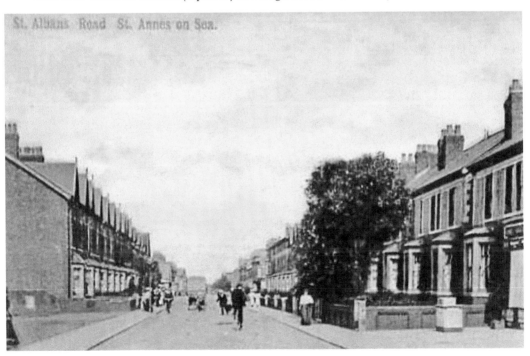

St. Albans Road St. Annes on Sea.

The Crescent II

Back to the bottom of The Crescent looking left up the bridge diversion from the St Annes Road East side. The lower picture is a more modern view from the top of the bridge, showing it all built up with shops on one side and trees on the other hiding the original road across the railway tracks via a level crossing. At the bottom of the hill on the right is Our Lady Star of the Sea Roman Catholic church, and in the distance the tower that was added to St Anne's parish church in 1890 is visible.

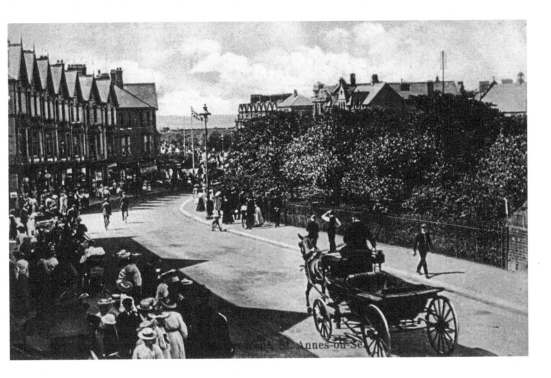

The Crescent III

A very busy day on The Crescent, a sight the shop owners of today can only dream about and wish would return. The picture was taken pre-1910 because in that year the Imperial Hydro (Majestic) was built in the space in the middle at the back. To the left is the top of St Andrew's Road South which the lower picture shows. Probably an old folks' tale but it is said that when the first houses were built on one side of the road only, some of the residents used to take pot shots at the rabbits in the sand dunes opposite with their shotguns.

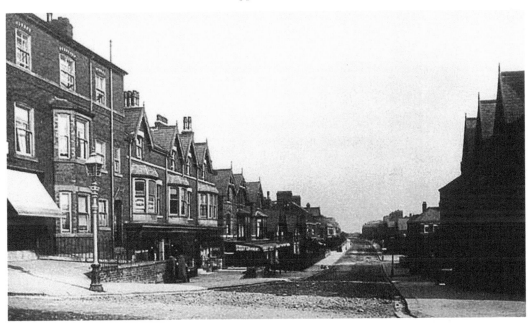

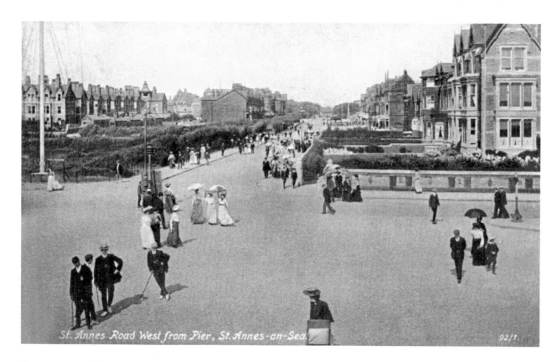

St Annes Road West I

This view of St Annes Road West as seen from the pier is again prior 1910 because as written earlier, the Majestic has not yet been built. The first building on the right was the Southdown Hotel but is now the Town Hall and the building on the left whose front is on North Clifton Drive became the Conservative Club but has now been demolished and a supermarket with apartments above built on the site. The lower postcard was taken on the pier end of St Annes Road West near its junction with North Clifton Drive. The large shop on the right was originally a hardware shop.

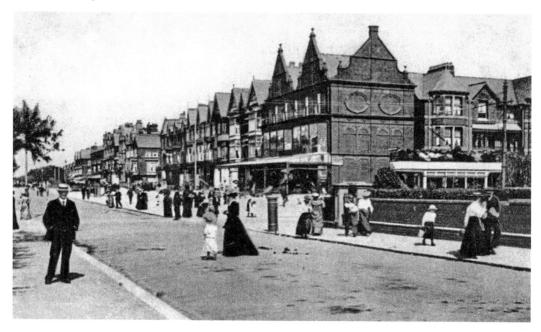

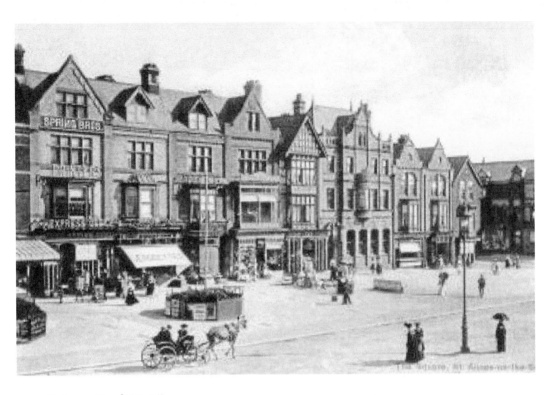

St Annes Road West II

A shop scene between Park Road and Orchard Road as seen from J. R. Taylor's department store (now closed down), Spring Bros. print shop was responsible for publishing some of the postcards of St Annes similar to the one on page 59. The lower picture was taken from the bank on the corner of Park Road, showing an aerial view of the sunny side of the square with the shop blinds down to protect the window displays.

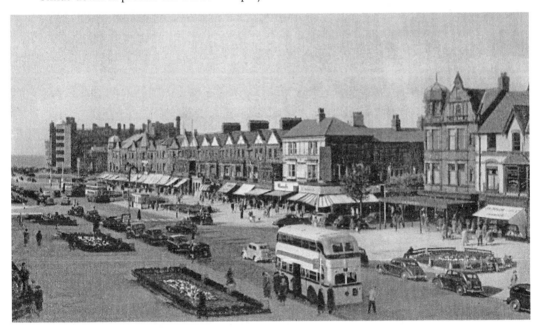

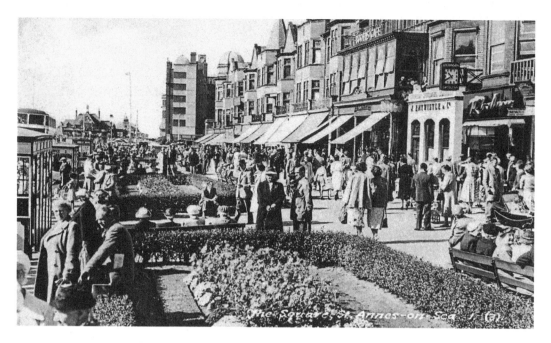

St Annes Road West III

A busy square on a sunny day and a case of standing room only with all the seats occupied; even Booths café seems to be busy with customers in the upstairs windows. The lower picture shows a quieter day, with its redesigned gardens and new seats; the shop fronts are also being modernised including Booths, now gone, the shop being used by an Express store with no café. Towards the end of the twentieth century the town, as a shopping area, went into a decline so more major extensive redevelopments took place, trying unsuccessfully and to revitalise the town, everyone wondering where have all the visitors gone.

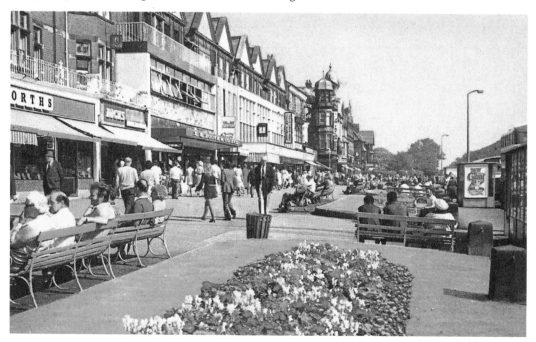

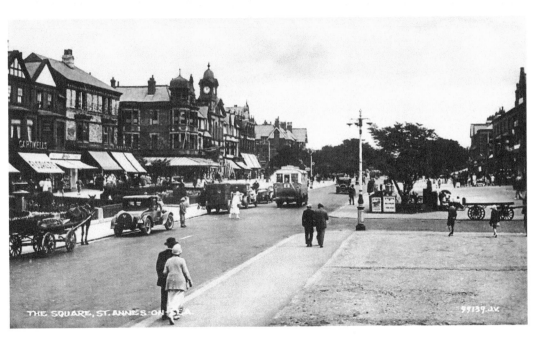

St Annes Road West IV

The square looking east, with the road being used by vehicles of various shapes and sizes. The shops owned by household names such as Cartmell's, Burgess Bros., Samuel's, J. R. Taylor's, Booths and many others have all disappeared from the square (sixteen of which are now charity shops) probably due to customers spending £2/3 travelling to out of town to supermarkets to save £4 at their expense. The lower picture shows the bus stops and shelters equally spaced between North Clifton Drive and Garden Street with cars parked on the other side of the road instead of all being crammed into a short space as they are today.

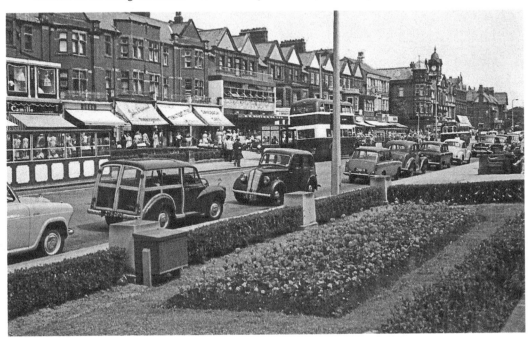

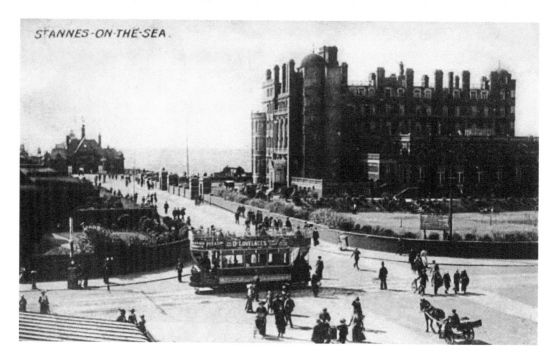

ST·ANNES·ON·THE·SEA.

Imperial Hydro I

The Imperial Hydro (hydropathic water treatment) Hotel was opened in 1910 but by 1920 this form of water treatment was in the decline so it changed its name to the Majestic and at the time was believed to have been the largest hotel in the county. At the same time Gerald Bright (Geraldo) formed his Majestic Celebrity Orchestra and became the resident musician for five years, making his first radio broadcast from here which he continued to do three times a week for two and a half years. The hotel was demolished in 1975. The bottom picture of the Square was taken from the same place as the Majestic above.

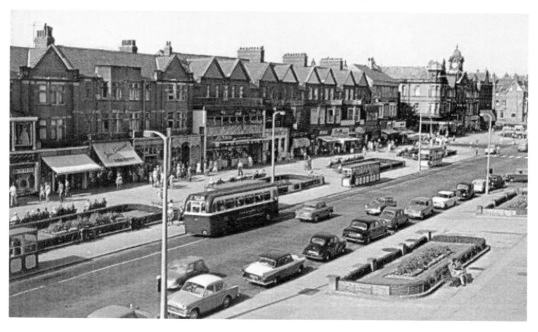

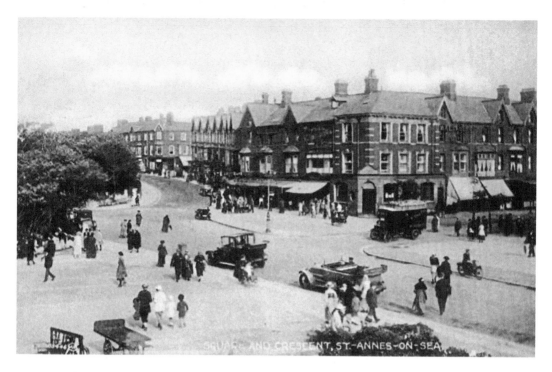

Aerial Views

One of J. R. Taylor's upper rooms was probably the vantage point where the top picture of The Crescent was taken from, whereas, the lower picture showing St Annes Road West looking inland to the level crossing over the railway line before it was diverted over a bridge to the right (The Crescent) was taken from high up in the Majestic Hotel and shows the old tram waiting room, bottom left, which is still in existence; now being used as a tea room, it has seating outside for when the weather is nice.

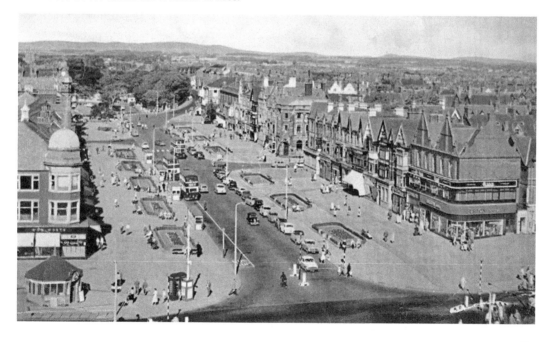

Advertising

There were numerous multi-view postcards showing two, four or six local background scenes with one main one in the centre showing another local scene or a picture of maybe a vehicle, people, animals or hotels etc. I have only included two, one because of its comical value and the other because it brings us back to where we started this section of St Annes: outside the railway station and the first building erected in the town, the St Annes Hotel, now called the Town House, which still retains the famous original Burlington Bar in the basement.

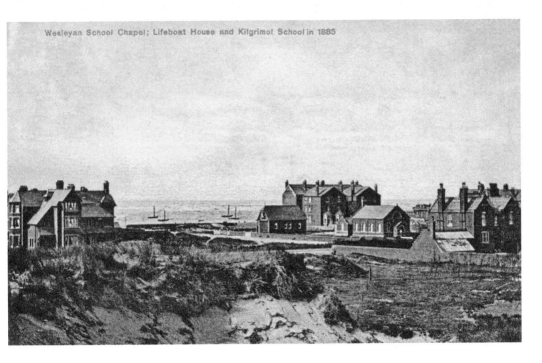

Early St Annes

St Annes was built among sand dunes, some quite high. The top picture was taken from one in the Bromley Road area showing Kilgrimol School on the left founded in 1875 by John Allen and his wife. After she died he retired, opening a herbalist shop in Park Road but committed suicide in 1913. The school, after lying empty for a few years, was converted into the St Annes District Club in the 1920s. To the right behind the Wesleyan Chapel is the old lifeboat house used between 1879–1925, now a funeral directors. The lower picture c. 1905 shows the Wesleyan Chapel has been replaced by the Drive Methodist Church.

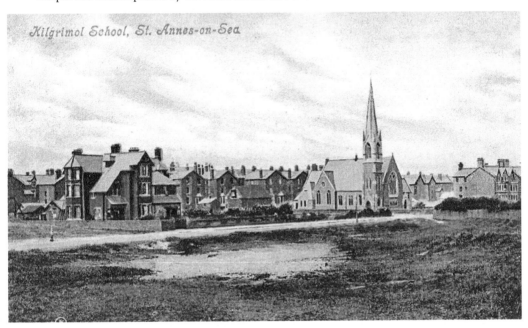

Kilgrimol School, St. Annes-on-Sea

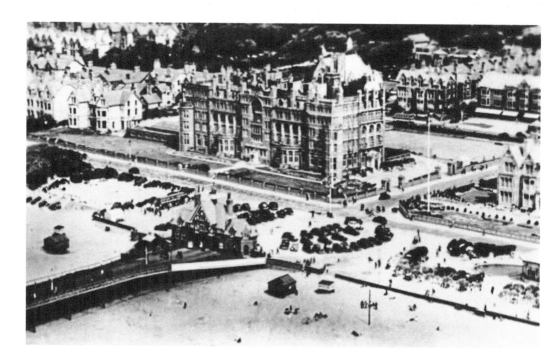

Imperial Hydro II

Famous for its water treatments, it became known as the Majestic when they went out of fashion. The main entrance was on the front, but due to high winds and drifting sand it was rarely used, the one on the side being used instead. It retained its ballroom with Geraldo as the bandmaster, and tennis courts. The hotel was demolished in 1975, being replaced by the inevitable block of apartments under the same name. A pub called the Lord Derby was built on the site of the tennis courts. In 2008 the circular flower bed was replaced by a sculpture of the comedian Les Dawson, who lived in the town.

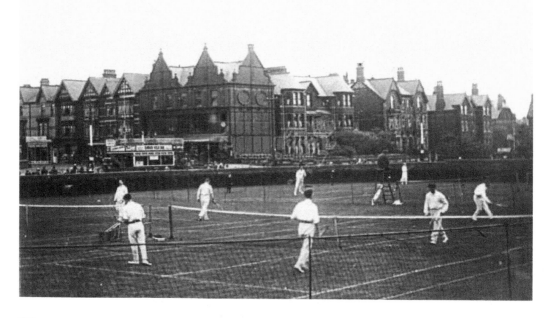

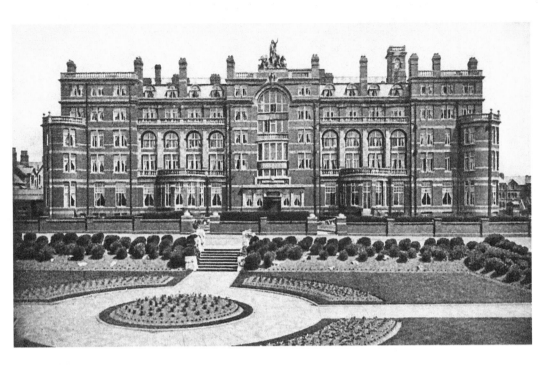

Majestic Hotel

The statue of Boadicea (some say Hygeia) on the roof of the Majestic holding a trident and driving a team of horses was removed during the Second World War the metal supposedly being used to help the war effort. My sand-grown friend Wally Stone related a story to me about a friend of his gaining access to the roof and hanging a chamber pot (gazunda) off one of the prongs on the trident for which he was severely reprimanded. The lower view of the promenade taken from the Majestic shows the apexes of the Southdown Hotel, now the Town Hall, and the boating lake beyond which is the open-air Roman baths.

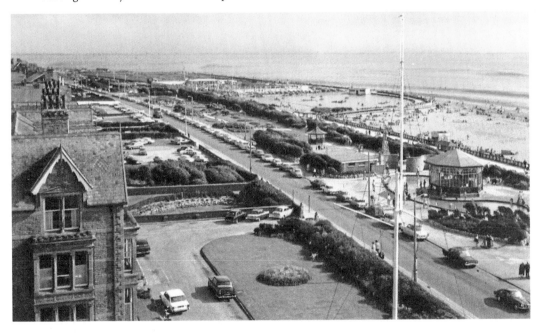

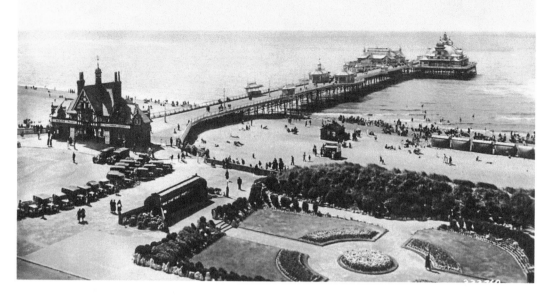

Pier I

From the Majestic Hotel the whole length of the 315-yard pier and its jetty out to the North Channel shipping lane can be seen. It was opened in 1885 and the jetty, with various heights of landing stages, was used by boats of various shapes and sizes plying their trade between Liverpool, Preston, Morecombe and beyond, including local pleasure craft. The pier was widened and the new pier entrance we see today was added in 1904. A view from near the pier head on the lower picture shows the Moorish Pavilion on the left and the Floral Hall on the right.

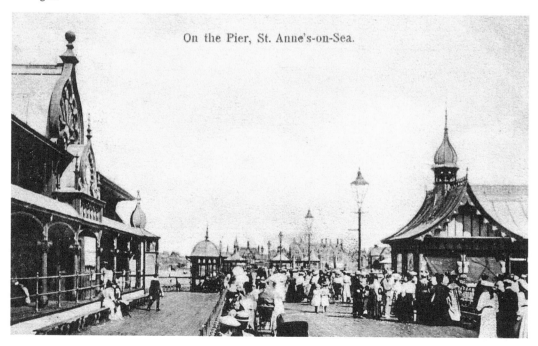

On the Pier, St. Anne's-on-Sea.

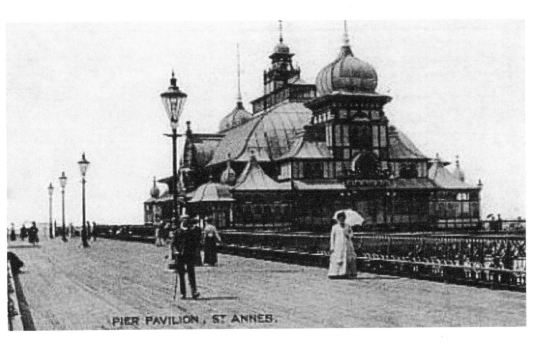

PIER PAVILION, ST ANNES.

Pier II

On the pier head was, on the right, the 1,000-seat Moorish Pavilion which was opened in 1804 when the pier was widened. From the 1970s it became known as the Sultan's Palace. On the left the Floral Hall opened in 1910 and where concerts, operas and vaudeville acts took place; it was refurbished in 1962 and turned into a Tyrolean-style beer garden. A fire in 1959 damaged the landing jetty and children's area. The Moorish Pavilion/Sultan's Palace was destroyed by fire in 1974 and the Floral Hall suffered the same fate in 1982, so the pier head was demolished as a result while they wondered where all the visitors have gone.

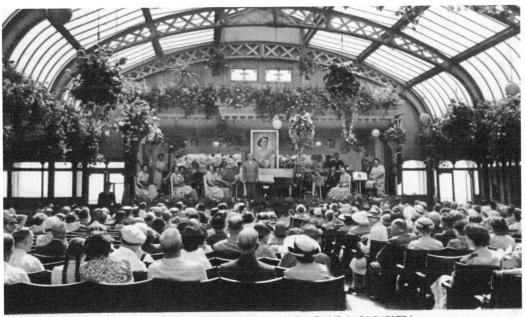

FLORAL HALL, THE PIER, LIONEL JOHNS & ORCHESTRA

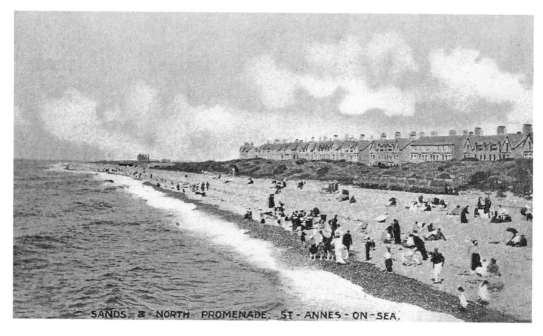

SANDS & NORTH PROMENADE. ST-ANNES-ON-SEA.

North/South Promenade

Using East Lancashire (Helmshore) stone and yellow bricks' Porritt built many of the houses on the sea front including these on the North Promenade as seen from the pier. In the distance the Ormerod Children's Home built in 1890 is visible; closing down, it was leased to Mencap for a short period before being demolished for yet more apartments on the sea front. The lower picture shows an undeveloped South Promenade with a bandstand, lifeboat monument and seating shelter. The spire of Drive Methodist Church built in 1892 on the site of the Wesleyan Chapel is also visible.

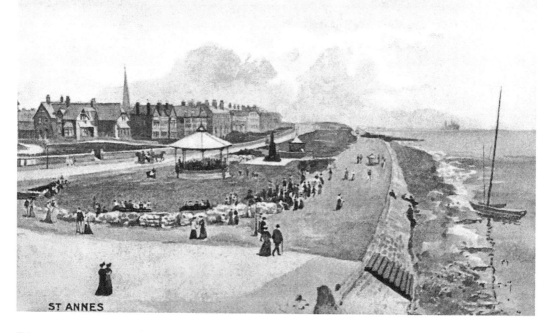

ST ANNES

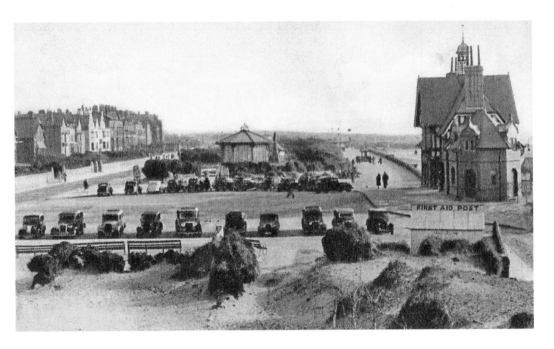

South Promenade I

Overlooking what is now a garden and past the pier entrance, the South Promenade and promenade walkway can be seen running parallel with each other with views of the developing promenade gardens containing a bandstand, lifeboat monument and shelter in between them as seen from a large sand dune, which is visible in the middle of the lower picture at the back (now a car park), on North Promenade. The lower view of the bandstand shows an open space on the right where the Imperial Hydro/Majestic was built in 1910. The bandstand is now partially surrounded by a paddling pool.

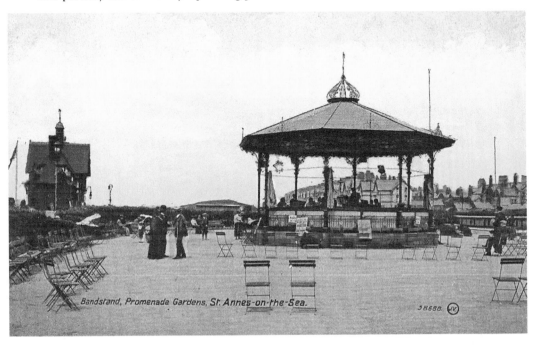

Bandstand, Promenade Gardens, St. Annes-on-the-Sea.

38588.

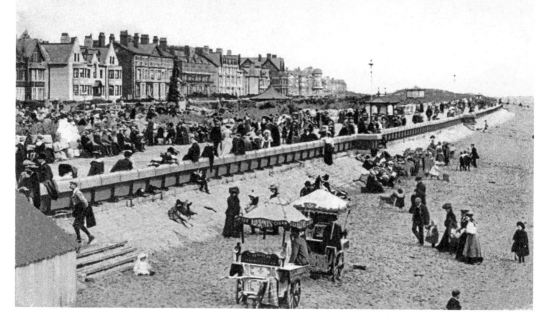

South Promenade II

These two postcards are of the beach south of the pier. The top view shows St Annes as a popular seaside resort with ice-cream sellers and donkeys plying their trade on the beach, sea defence walls have been installed and the shrubs in the gardens are becoming established. In the lower postcard everybody seems to be enjoying themselves, but what are the children digging for? It must have been just as windy in those days judging by the number of wicker beach chairs there are in the picture. In the background on the right are the apexes of the Collegiate School, now the St Ives Hotel.

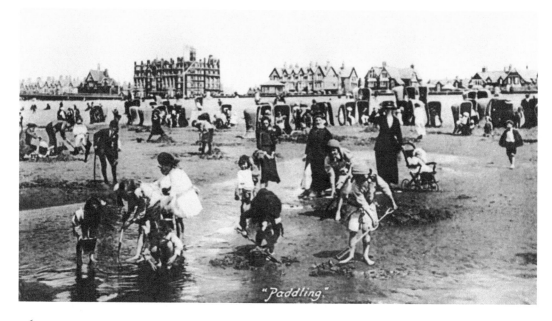

"Paddling."

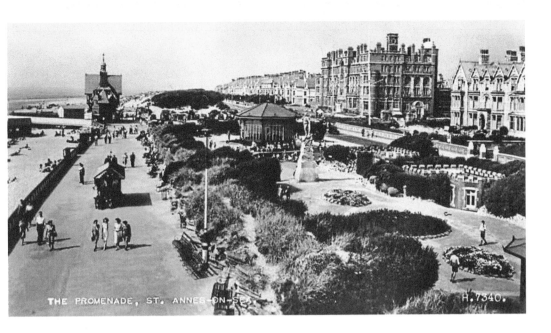

THE PROMENADE, ST. ANNES-ON-SEA. H.7340.

South Promenade III

In this aerial view of the South Promenade it seems that in the early 1900s public toilets should not be seen so were built underground, the toilets in Lytham were unground in Clifton Square under what is now the piazza as were these on the promenade with battlement-style roofs. The Victorian fountain below, now brightly painted, is, according to the caption on the card, in the Esplanade Gardens which were constructed between 1907 and 1914. The buildings at the back have been demolished, the one on the right becoming an extension to the Dalmeny Hotel and the one with the ornate apexes is now the Inn on the Prom.

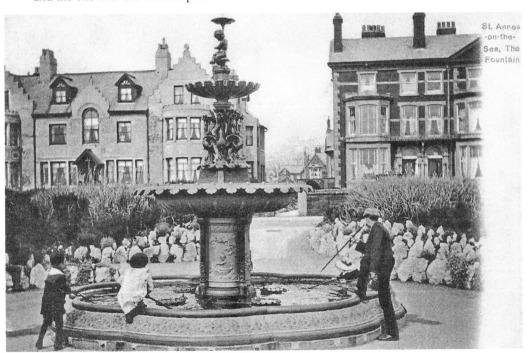

St. Annes
-on-the-
Sea, The
Fountain

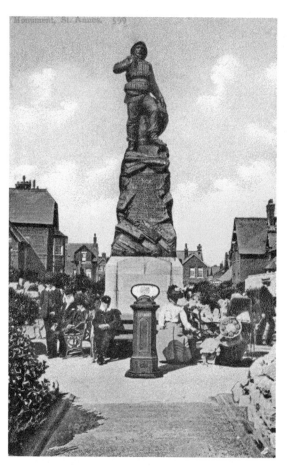

The Lifeboat Disaster

The monument, unveiled in May 1888, is in memory of the worst accident in lifeboat history when thirteen crewmen on the lifeboat *Laura Janet* from St Annes and fourteen on the lifeboat the *Eliza Fernlea* from Southport lost their lives trying to save the crew from the barque *Mexico* which had run aground in the River Ribble during a storm in December 1886. The loss of these men left sixteen widows and fifty children fatherless. Five days before this, the crew of the St Annes lifeboat had saved the lives of six men from the ship *Yan Yean* near Salter's Bank.

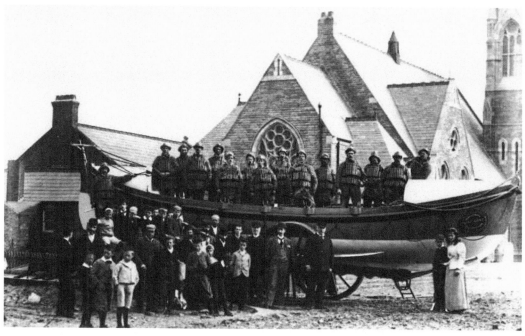

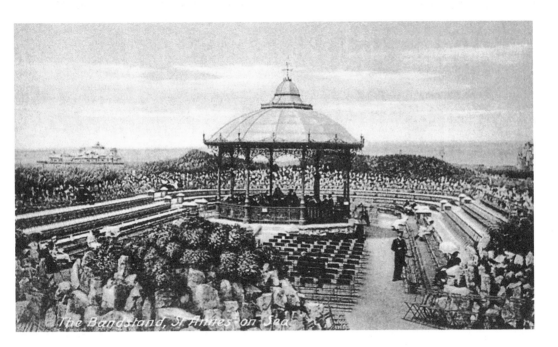

The Bandstand, St Annes-on-Sea

Paddling Pool

The bandstand in the Amphitheatre on South Beach opposite Hornby Road and the De Vere Gardens apartments was removed when it was decided that only one was necessary on the sea front; the open area left was used for shows before being converted into a paddling pool now barely visible behind the sand dunes and shrubs. According to an article in the local paper on 25 August 2004 plans were afoot to fill it in and plant it up with shrubs; at the time of writing February 2016 this has not been done but it is not filled with water very often for children to play in.

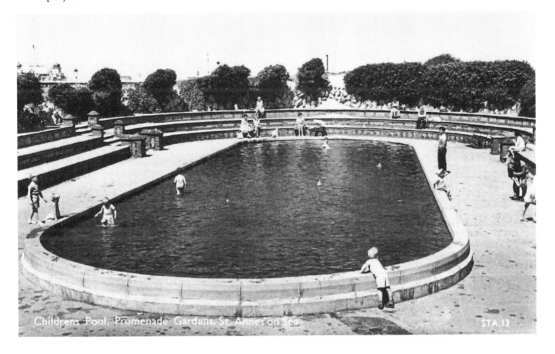

Childrens Pool, Promenade Gardens, St. Annes on Sea STA.13

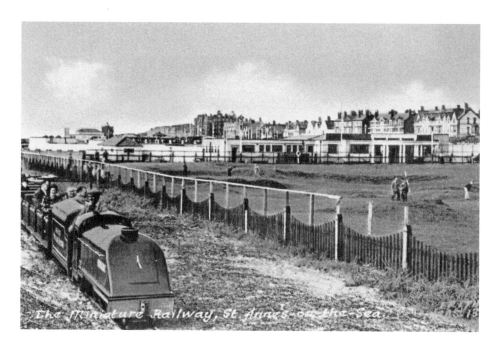

The Miniature Railway, St Anne's-on-the-Sea

Entertainment on the Promenade

A 15-inch-gauge miniature train operated near where the present one is from 1952, closing down in 1970. Now two miniature trains run on a 10¼-inch-gauge track that opened in 1973 on a course predominantly rectangular in shape encircling a miniature golf course: they are the *St Annes Express* from 1973 and *Harry's Dream* from 2005, a big attraction for the young and old alike since it opened. There is also another well-used pitch-and-put golf course in the promenade gardens between the wide promenade walkway that goes from the pier to Beach Café and the South Promenade road as seen in the lower picture.

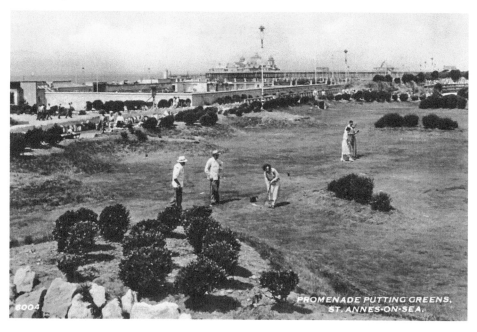

PROMENADE PUTTING GREENS, ST. ANNES-ON-SEA.

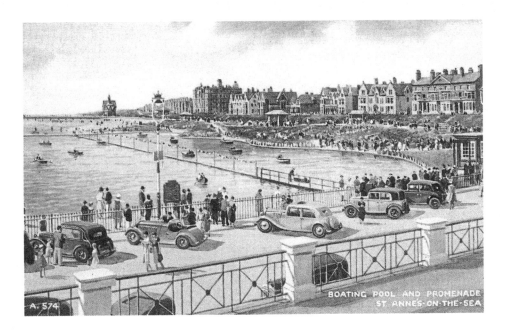

Boating Lake

The coloured postcard of the boating lake was taken from the sun terrace on the open-air swimming pool and the bottom one from the promenade gardens. One of the main reasons visitors flocked to the Fylde in the first place was anything to do with water, such as the sea and open air/indoor baths, paddling/model boating pools, ornamental fountains and boating lakes. Only the latter, probably due to low maintenance costs, have survived the apparent obsession of the various councils since the 1980s, from Fleetwood to Lytham, to get rid of anything to do with water to save money, while wondering where all the visitors have gone.

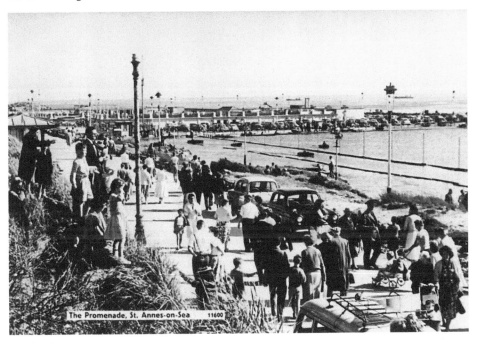

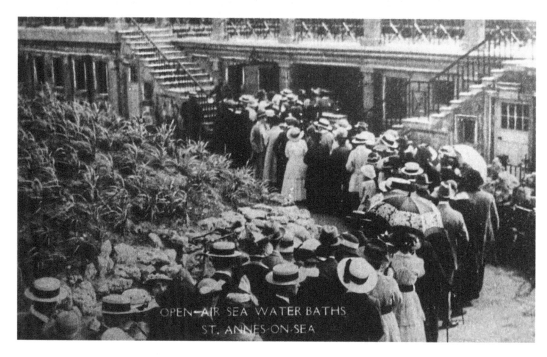

Roman Baths I

Long queues patiently waiting to gain access to the open-air Roman baths which were opened in 1916; being 50 yards long and 40 wide they were filled with filtered sea water. In the 1950s they were often used for bathing beauty contests and junior and senior swimming galas and in the lower picture there appears to be a diving competition in progress because there are no bathers at the diving end and the fully dressed spectators seem to be intently watching and evaluating the execution of the somersault dive being performed.

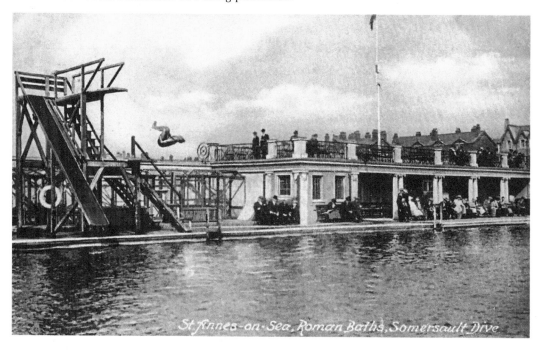

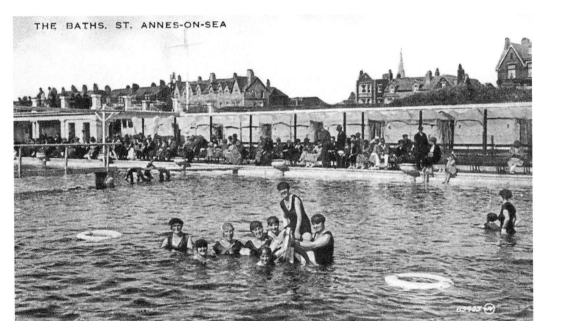

Roman Baths II

The baths were a very popular venue as the coloured postcards show with sunbathing on the terraces and children and adults enjoying themselves using the tall slide at the south end and the small slide and diving platform at the other, beyond which can be seen the boating lake and pier. In the mid-1980s it was estimated that, probably due to the lack of ongoing maintenance, it would cost £10,000 to refurbish them so in 1988/89 they were closed and in 1992 demolished, being replaced by what is not worth describing, and they wondered where all the visitors have gone.

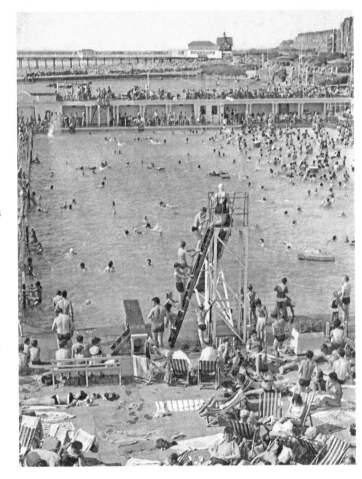

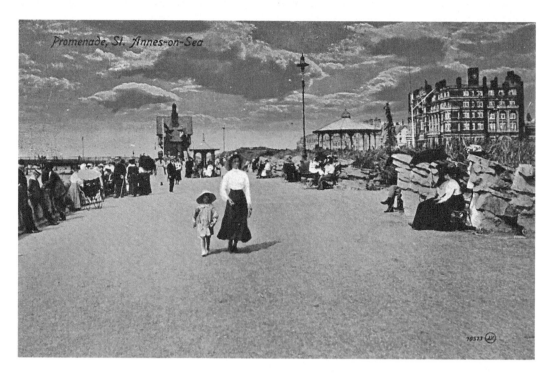

Promenade, St. Annes-on-Sea

Night-time

In the early days the sea front was just as popular with people having a safe evening stroll along the promenade on a nice warm moonlit night as the top postcard dated 1915 shows; the lower postcard which was produced from a photograph shows an equally busy night-time beach with men and boys standing on what appears a concrete wall protruding out onto the beach from the promenade.

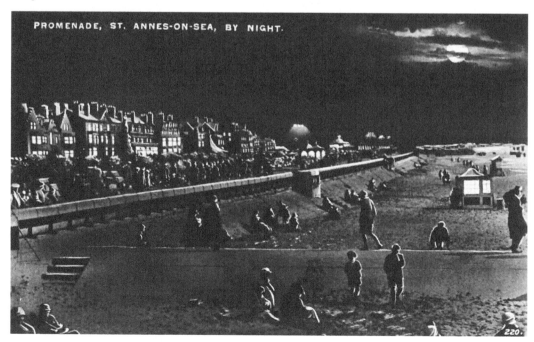

PROMENADE, ST. ANNES-ON-SEA, BY NIGHT.

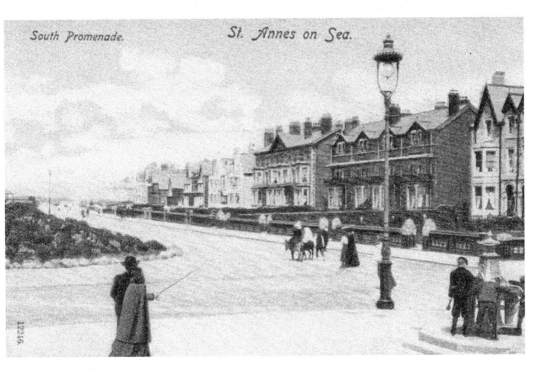

South Promenade. St. Annes on Sea.

South Promenade

These two postcard views were taken from roughly the same point, the junction of the South Promenade and Eastbank Road. The promenade gardens were laid out between 1907 and 1914. In both views all the houses had lovely front gardens but today not only have most of the houses been replaced by hotels but the gardens have been tarmacked over for carparks. In 1954 waiters' and waitresses' races took place on the South Promenade; the contestants had to have a towel over their arm while balancing a glass on a tray and run over a set distance, Brian Cowap won the men's race and Edna Allinson won the ladies.

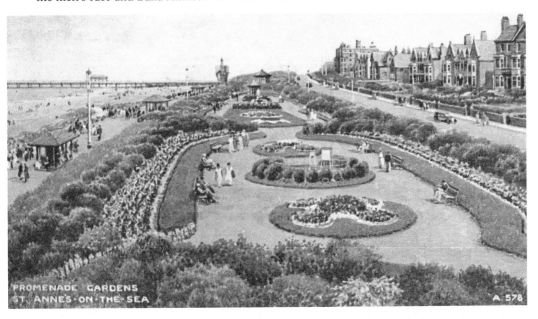

PROMENADE GARDENS
ST. ANNES-ON-THE-SEA A 578

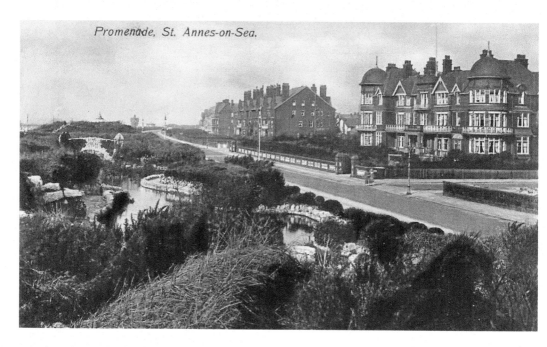

Promenade, St. Annes-on-Sea.

Promenade Ornamental Gardens I

A decision was made to create a garden with water features in the sand dunes separating the wide promenade walkway from the South Promenade road south of the pier. This took place between 1907 and 1914, with Messrs Pulham & Sons, who had already, in 1913/14, done work in Ashton Gardens, being employed to install a water feature better than any other, with an informal lake of interlinked shallow ponds containing islands, stepping stones, a bridge and a grotto situated under a dual cascading waterfall.

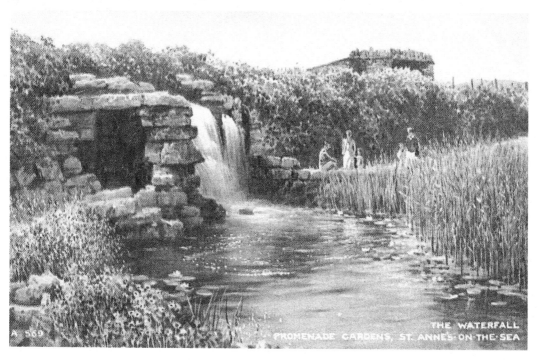

THE WATERFALL
PROMENADE GARDENS, ST. ANNE'S-ON-THE-SEA

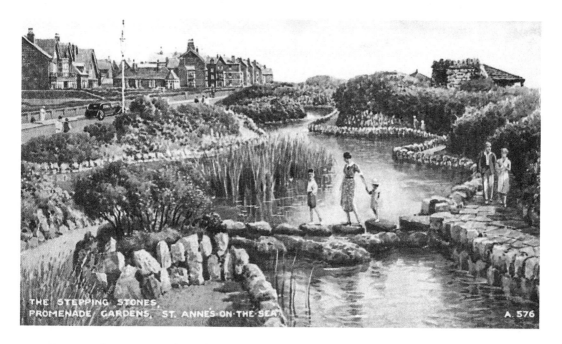

THE STEPPING STONES,
PROMENADE GARDENS, ST. ANNES-ON-THE-SEA

A. 576

Promenade Ornamental Gardens II

It took nearly 1,000 tons of rock from Derbyshire and Clitheroe to complete the construction, the whole of which was encircled by a footpath that went under the grotto, a favourite place for newlyweds to have some memorable photographs taken. When the waterfall was first built 350 gallons (nearly 1,600 litres) of water per minute were pumped over it, falling into the ornamental lake below. On top of the sand dunes by the lake a footpath was established running south with an alpine and herbaceous garden created on either side of it. When finished the area was considered to be the prettiest in the country.

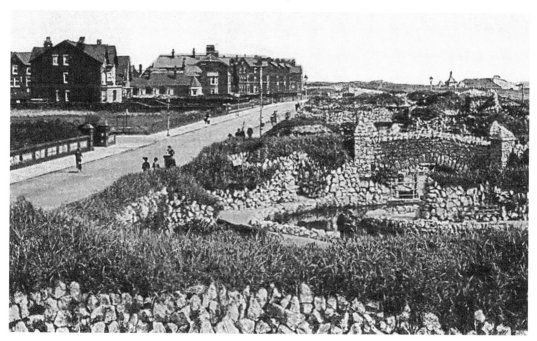

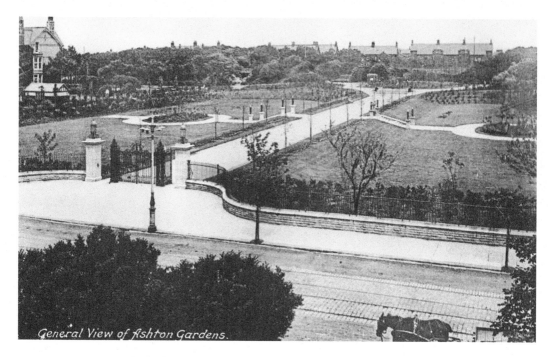

General View of Ashton Gardens.

Entrance I

There are two main entrances to Ashton Gardens; this one on North Clifton Drive was erected after 1914 when Lord Ashton bought what was St George's Gardens and an extra piece of land next to North Clifton Drive, part of which had been used as a builder's yard by Porritt when he was building houses in the town. A lot on the sea front, many of which, apart from the Town Hall, have been replaced by modern hotels and apartments in the name of progress. The War Memorial was unveiled in 1923 in memory of the local servicemen who lost their lives during the First World War.

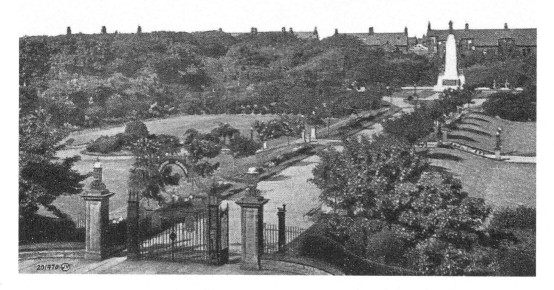

ENTRANCE, ASHTON GARDENS, ST. ANNES-ON-SEA

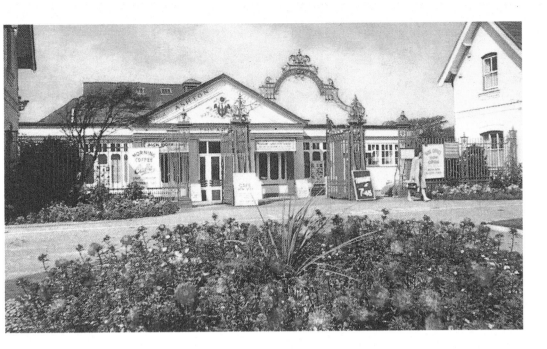

Entrance II

St George's Road entrance stood in front of the popular Ashton Pavilion Theatre; the theatre suffered a minor fire in 1964 which damaged the stage and some seats but was soon up and running again. In 1975 due to financial reasons and being under threat of closure, the Fylde Borough Council took it over. Unfortunately, in 1977, disaster struck again when another fire completely destroyed the fifty-year-old theatre and the council, going against the townsfolk and theatregoers' wishes decided not to rebuild it, wondering where have all the visitors gone. The lower picture shows a pathway leading into the park from a minor entrance from Beach Road.

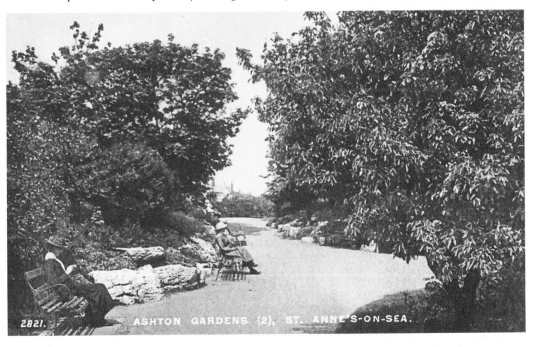

2821. ASHTON GARDENS (2), ST. ANNE'S-ON-SEA.

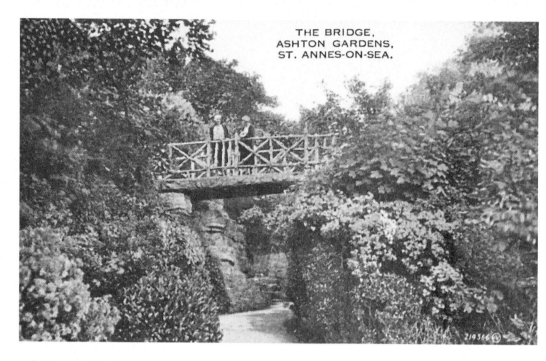

THE BRIDGE,
ASHTON GARDENS,
ST. ANNES-ON-SEA.

Ashton Gardens I

The following pictures of Ashton Garden are, by their captions self-explanatory, so I thought a brief history of the gardens would be appropriate here. Elijah Hargreaves who had made his fortune in the cotton industry in Rossendale persuaded seven equally wealthy Rossendale businessmen to join him and form the St Anne's Land & Building Co. to oversee his vision of a town called St Annes (named after the parish church built further inland by the Clifton Family) among the sand dunes on the coast between Lytham and Blackpool.

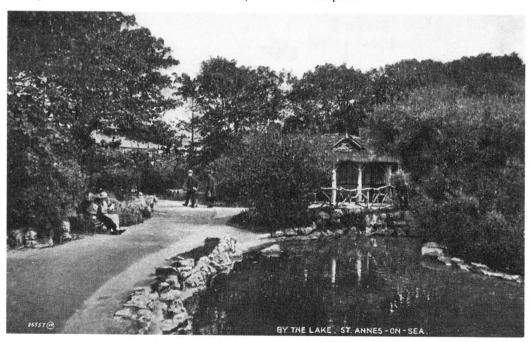

BY THE LAKE, ST. ANNES-ON-SEA.

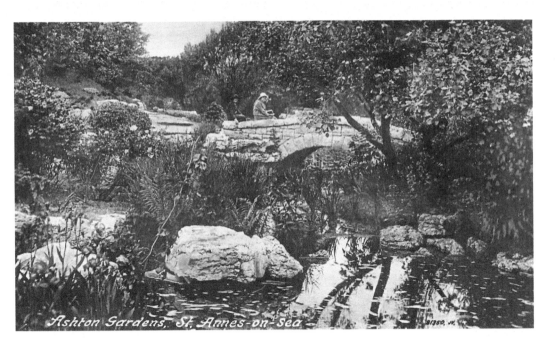

Ashton Gardens, St. Annes-on-Sea

Ashton Gardens II

At the same time the company created between 1875 and 1877 a recreational garden using the contours of the sand dunes as the theme, calling them St George's Gardens; due to setbacks etc. in the early years, and the inevitable rumours of the land being built on by another businessman, Lord Ashton. He owned and lived in The Bungalow in the sand dunes when he was in town. Having made a fortune in the linoleum and floor-covering business in his factories on the River Lune in Lancaster, he bought them in 1914 with an extra piece of land abutting North Clifton Drive roughly covering 10 acres in total.

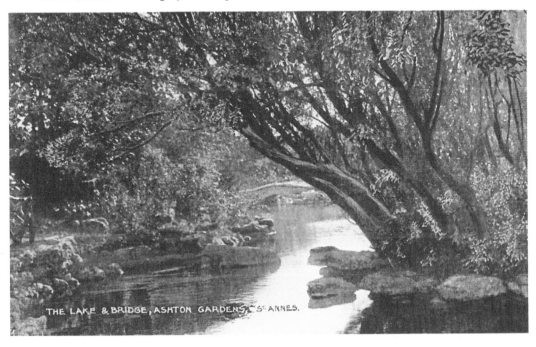

THE LAKE & BRIDGE, ASHTON GARDENS, ST. ANNES.

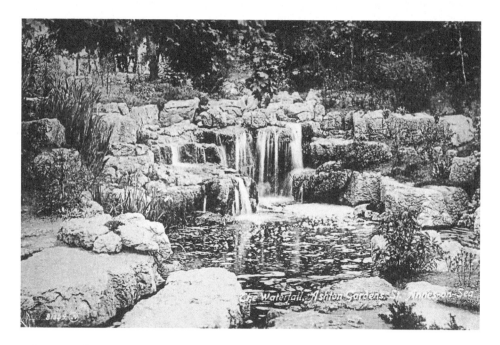

The Waterfall, Ashton Gardens St Annes-on-Sea

Ashton Gardens III

Lord Ashton donated this 10 acres of ground/gardens which were bounded by St George's Square, Beach Road, St Andrew's Road North, St George's Road and North Clifton Drive to the town and they were officially opened in 1916 as Ashton Gardens in his honour. The aforementioned Messrs Pulham & Sons constructed a large rock and water garden which consisted of waterfalls flowing through stepping stones (some of which have been removed to the bank for safety reasons) under the inevitable Pulham Bridge to a lake with a fountain in it. Further additions over the years included bowling greens, tennis courts and a children's play area.

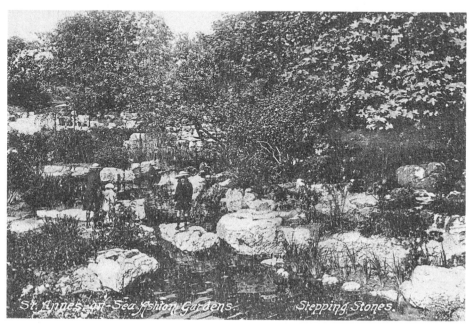

St Annes-on-Sea Ashton Gardens. Stepping Stones.

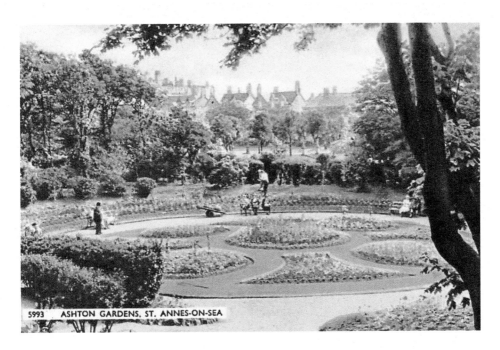

5993 ASHTON GARDENS, ST. ANNES-ON-SEA

Ashton Gardens IV

There were two areas designated as tennis courts, one near the entrance on St George's Road which has long gone and the area now used for skateboarding/rollerblading and a basketball court. The other was in front of the colonial-style building known as the Ashton Institute but was replaced by a more popular bowling green. The Institute building, the Empire de Lux cinema/bingo hall behind it on St George's Road and the car showrooms next to it stood in the way of a proposed development of apartments and the developers promised to dismantle the institute and rebuild it behind where the theatre once stood by the entrance.

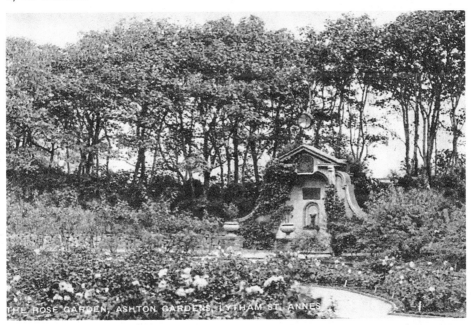

THE ROSE GARDEN, ASHTON GARDENS, LYTHAM ST. ANNES

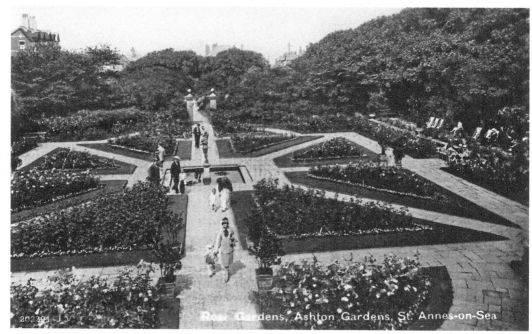

Rose Gardens, Ashton Gardens, St. Annes-on-Sea

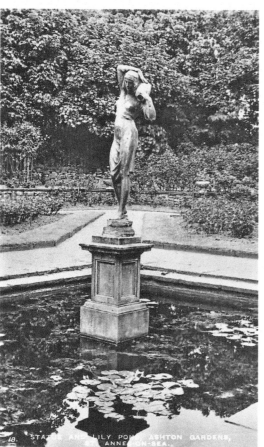

STATUE AND LILY POND, ASHTON GARDENS, ST. ANNES-ON-SEA.

Ashton Gardens V

Building permission being granted, the developers built an up-market colonial-style café behind the entrance on St George's Road, but because of dry rot and woodworm, of what they had saved from the original Ashton Institute little was used in its construction. Major restoration took place in the gardens with a £2 million grant from the lottery fund in 2010 which was spent on refurbishing the lodges and gates at the St George's entrance (not yet completed), perimeter fences and resurfacing the footpaths etc. Another grant from the Heritage Lottery Fund was given for the full refurbishment of Lord Ashton's Monument overlooking the rose gardens and fountain.

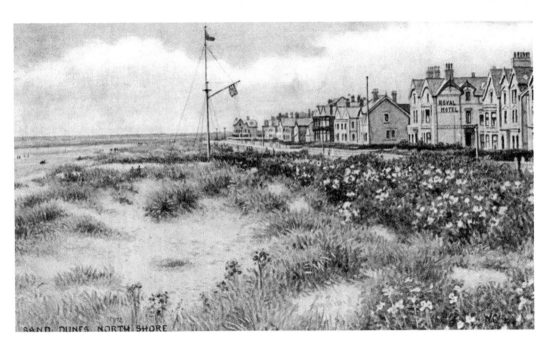

SAND DUNES NORTH SHORE

Murder in the Sand Dunes

It is said every good book should have at least one murder and this book is no exception.

On the morning of Christmas Eve 1919 John Gillett, a local man, was crossing the sand dunes on North Promenade when he came across the body of a young woman, the state of the sand around her suggesting she had put up a struggle with her assailant. The police were called and going through her possessions they found a bank book that identified her as Mrs Kathleen Elsie Breaks, aged twenty-five years from Ryecroft Farm, Dudley Hill, Bradford; other evidence was found including a letter from a Fairhaven resident and later on in the day as he was leaving a Lytham hotel, Mr Frederick Rothwell Holt of Lake Road, Fairhaven was apprehended and brought to St Annes Police Station on Christmas morning and charged with her murder.

Holt, a man of independent means, was tall, dark and handsome with a military moustache and was well known in St Anne's; after a short spell with the 4th Battalion North Lancashire Regiment (Territorials) in France during the First World War, he was invalided out suffering from shell shock and depression.

Kathleen was considered to be the most beautiful girl in Bradford and was married when she was eighteen years old, keeping it a secret for three years.

Separated from her husband, and against her mother's wishes, she left home for a stay in Blackpool on the 22 December where after having a meal at the Palatine Hotel she asked the way to Lytham. Her body was found in the isolated sand dunes wearing a diamond ring with a wedding ring in her pocket. At first she was thought to have been stabbed to death until a six-chamber Webley revolver with four empty cartridges was found half hidden nearby; after searching the area of the murder again, the police found some bullets in the sand, and the doctor found some in Kathleen; she had been shot three times. Police inquiries showed that the gun had been purchased from a Preston gunsmith in 1914 by Holt. They also found that Kathleen and Holt had met in a Fylde Hydro in 1918 and Holt, besotted by her, visited her many times when she returned home to Bradford. They also found out that she had insured herself for £5,000 with Holt paying the premiums and that she had made a will in which Holt was to be the recipient of the largest part of the insurance money.

Holt was held in Strangeways Prison and committed for trial at Manchester Assizes. After a trial lasting five days, he was found guilty and sentenced to death which took place on 13 April 1920 at Strangeways.

ABOUT THE AUTHOR

Photograph taken by Megan Skye Procter, the author's 4¾-year-old great-granddaughter.

Born in mid-Cheshire and educated at Davenham and Kingsley state schools and Asletts College and Belmont Hall private schools. Time-served electrician at ICI Northwich. Married in Northwich to Audrey Thompson who was responsible for my liking of photography by buying me my first camera. We moved to the Fylde about forty-five years ago with our daughter Alison and our faithful dog, Sheltie, a Shetland sheepdog who allowed us to live with her for seventeen years until she died, to become shop owners in Blackpool followed by a guest house and later another shop, this time in St Annes. We then got a position with a management company as house managers of two blocks of privately owned retirement apartments in St Annes until we retired in 2006. With an interest in local and family history, I started writing books for Amberley Publishing in 2012.